ANSEL ADAMS

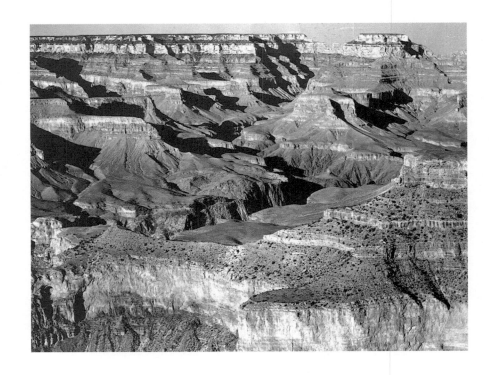

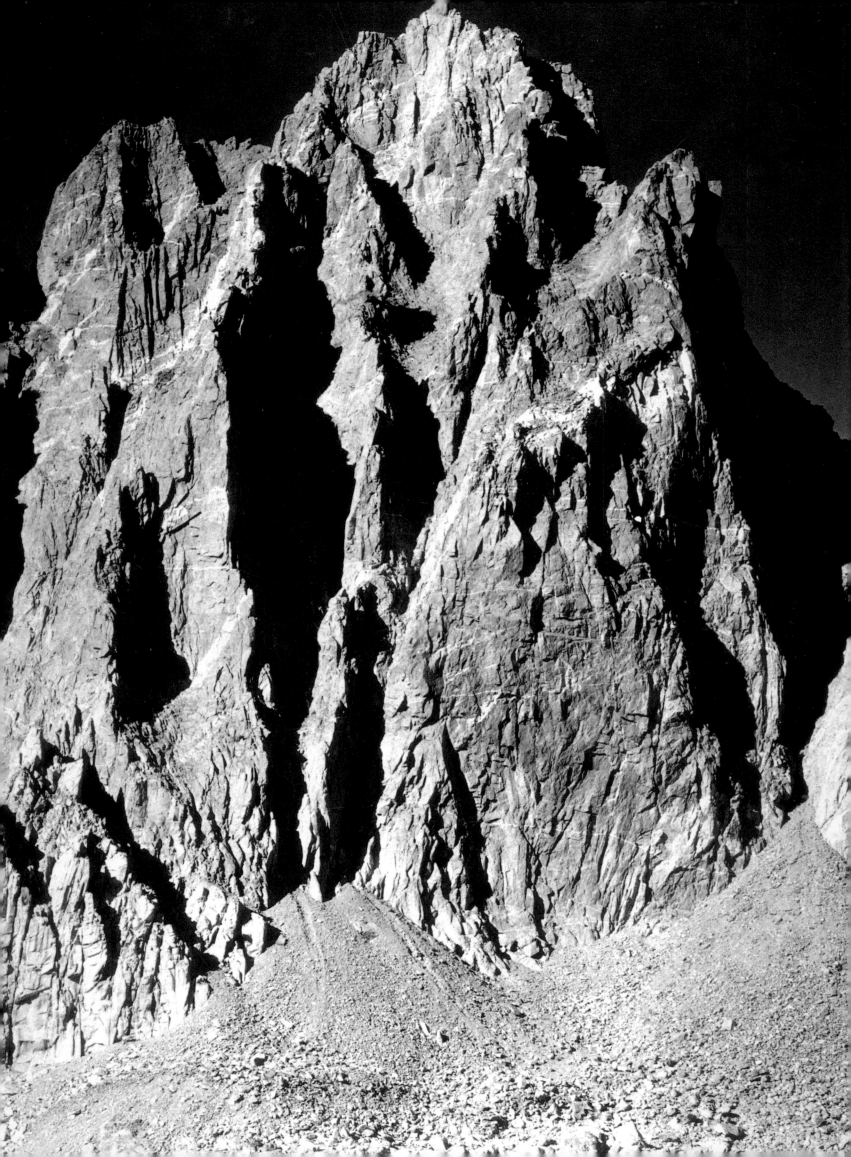

ANSEL ADAMS

KATE F. JENNINGS

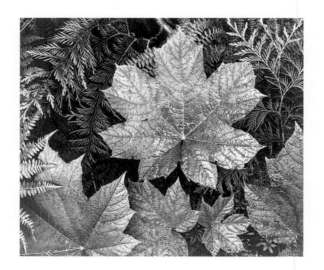

MetroBooks

MetroBooks

An Imprint of Friedman/Fairfax Publishers

This edition published by Metrobooks by arrangement with Belden Hi l Press LLC

ISBN 1-58663-764-9

1 3 5 7 9 10 8 6 4 2

For bulk purchases and special sales, please contact:

Friedman/Fairfax Publishers

Attention: Sales Department

230 Fifth Avenue, Suite 700

New York, NY 10001

212/685-6610 FAX 212/685-3916

Visit our website:
www.metrobooks.com

Printed in China

PHOTO CREDITS

All photographs courtesy of The National
Archives except the following:

Aperture Foundation: Paul Strand,
"The White Fence, Port Kent, NY, 1916,"
© 1971, Paul Strand Archive: 14 (top).

Huntington Library, San Marino, Ca., Rare
Book Dept., Historical Photographs: 27.

Museum of New Mexico, Santa Fe,
New Mexico, Photo Archives: 25.

San Francisco Museum of Art: Imogene
Cunningham, "Magnolia Blossom, 1925,"
gelatin silver print, 9 3/16 x 11 5/8 in., The
Henry Swift Collection, Gift of Florence
Alston Swift, Photo by P. Galgiani,
63.19.112: 20.

UCLA, University Research Library:
Eadweard Muybridge, "Falls of the Yosemite
from Glacier Rock," albumen print, Dept.
of Special Collections: 9.

UPI/Corbis-Bettmann: 7, 8 (both), 10,
11, 12, 13, 14 (bottom), 17 (both), 23, 24,
28, 31 (both). 32.

Page 1:
GRAND CANYON NATIONAL PARK
Grand Canyon National Park, Arizona

Page 2:
MOUNT WINCHELL
Kings River Canyon, California

Page 3:
IN GLACIER NATIONAL PARK
Glacier National Park, Montana

Page 6:
CANYON DE CHELLY
Canyon de Chelly, Arizona

Page 7:
*Ansel Adams in 1961, already established
as one of the world's leading photographers.*

This book has not been authorized by and
has no connection with Ansel Adams and
the Ansel Adams Publishing Rights Trust.

CONTENTS

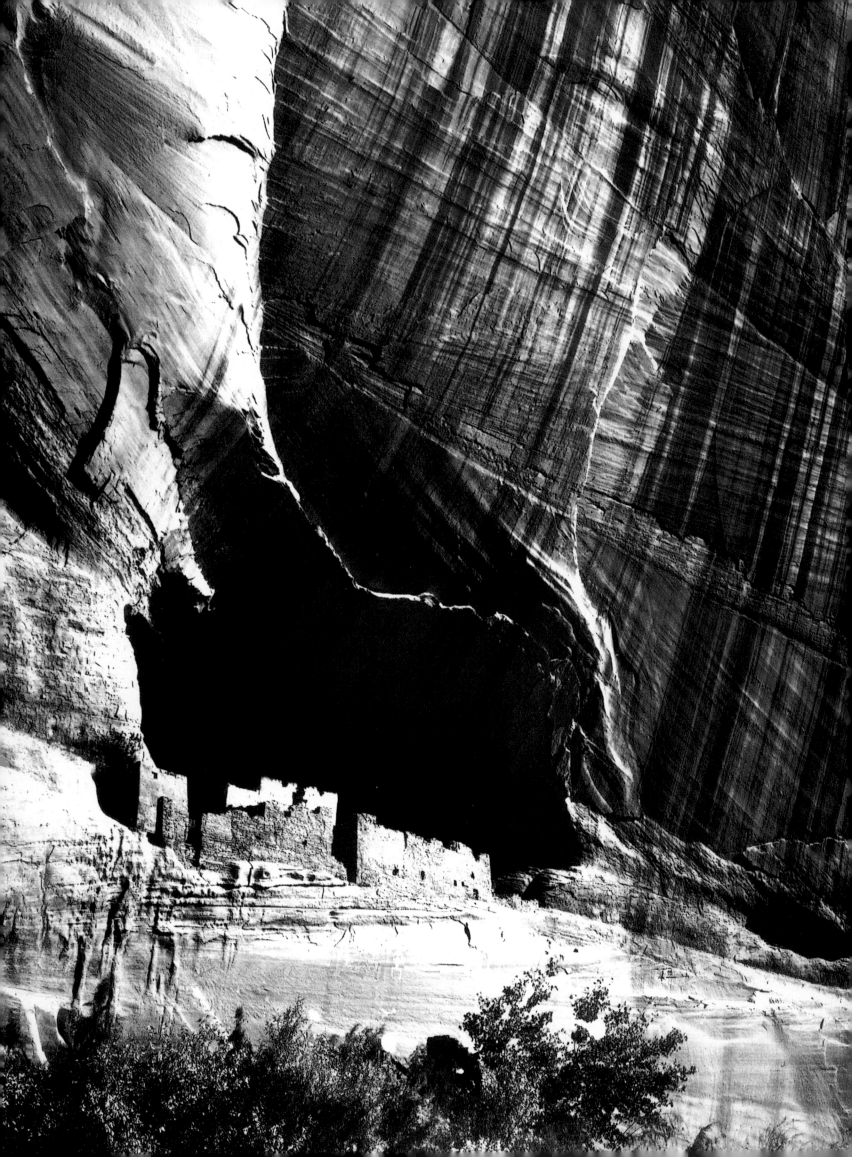

INTRODUCTION

But look how noble the world is,
The lonely-flowing waters,
the secret-keeping stones,
the flowing sky.

— ROBINSON JEFFERS

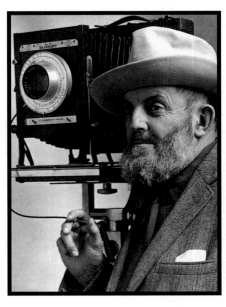

Ansel Adams was a twentieth century man, a photographer who used the technical virtuosity of his medium to portray the panoramic beauty of the American West. And yet, he belongs to the artistic continuum that began with the legendary landscape painters of the nineteenth century: Albert Bierstadt, Thomas Moran and Sydney Laurence. Like these brave explorers of an earlier era, Adams devoted his life to describing the majesty, romantic light and haunting drama of the American West: Yosemite, Big Sur, the Grand Canyon, the mountains and lakes of Montana, and the Alaskan frontier.

Adams revered the natural world and his pictorial record of America is optimistic and bold. His peaks and valleys match the crescendos and brio of the American composer Aaron Copeland particularly in his work, *Appalachian Spring.* Nature is the inspiration in Adams' photographs, interpreted with vigor and esprit.

In Adams' work, sheer rock cliffs loom precipitously over tiny pueblos. Saguaro cacti rise up like venerable ancient relics, both figural in demeanor and monumental in scale. Although Adams rarely photographed people, one can espy craggy profiles in his portraits of the Grand Canyon. His primary focus, however, was the accurate and at times startlingly direct description of geographical phenomena and his manner of cropping his photos often give these perspectives an abstract appearance. Intriguing patterns and vivid contrasts of light and dark were paramount.

Mount Ansel Adams, named after the photographer, is 11,760 feet high and stands at the Lyell Fork of the Merced River in Yosemite National Park. Adams' enchantment with the great parks and spacious skies of the West began in Yosemite, on his first visit there at age 14.

Adams was a native of San Francisco, born on February 20, 1902. An indifferent student, his

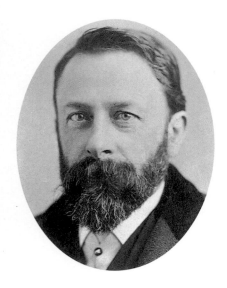

ABOVE: *Albert Bierstadt, a painter of the Hudson River School, painted many magnificent views of the West. His work provided inspiration for Adams.*

BELOW: *Albert Bierstadt's painting* Yosemite Valley, 1868.

RIGHT: *Eadweard Muybridge's 1872 photograph "Falls of the Yosemite from Glacier Rock." Yosemite is where young Adams first fell in love with the Western landscape.*

artistic awakening began when his father, Charles, took him out of school at age 13 and gave him a sabbatical year at the Panama-Pacific International Exposition in hopes that his son would be inspired to achieve, by viewing the exhibits on display.

The event was held in San Francisco in 1915 to celebrate the opening of the Panama Canal. Adams and his father toured a variety of pavilions, most notably the hall containing modern art by European painters such as Cezanne, Gauguin and Monet. It is interesting to note that Adams' early photographic efforts had an impressionistic style not unlike the painterly techniques that prevailed during the first two decades of the twentieth century.

At this time Adams also revealed a talent for the piano and was taught at home by tutors and

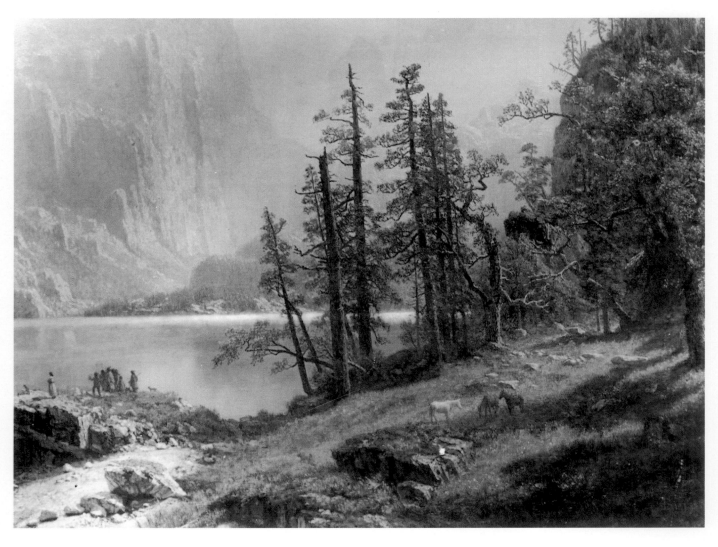

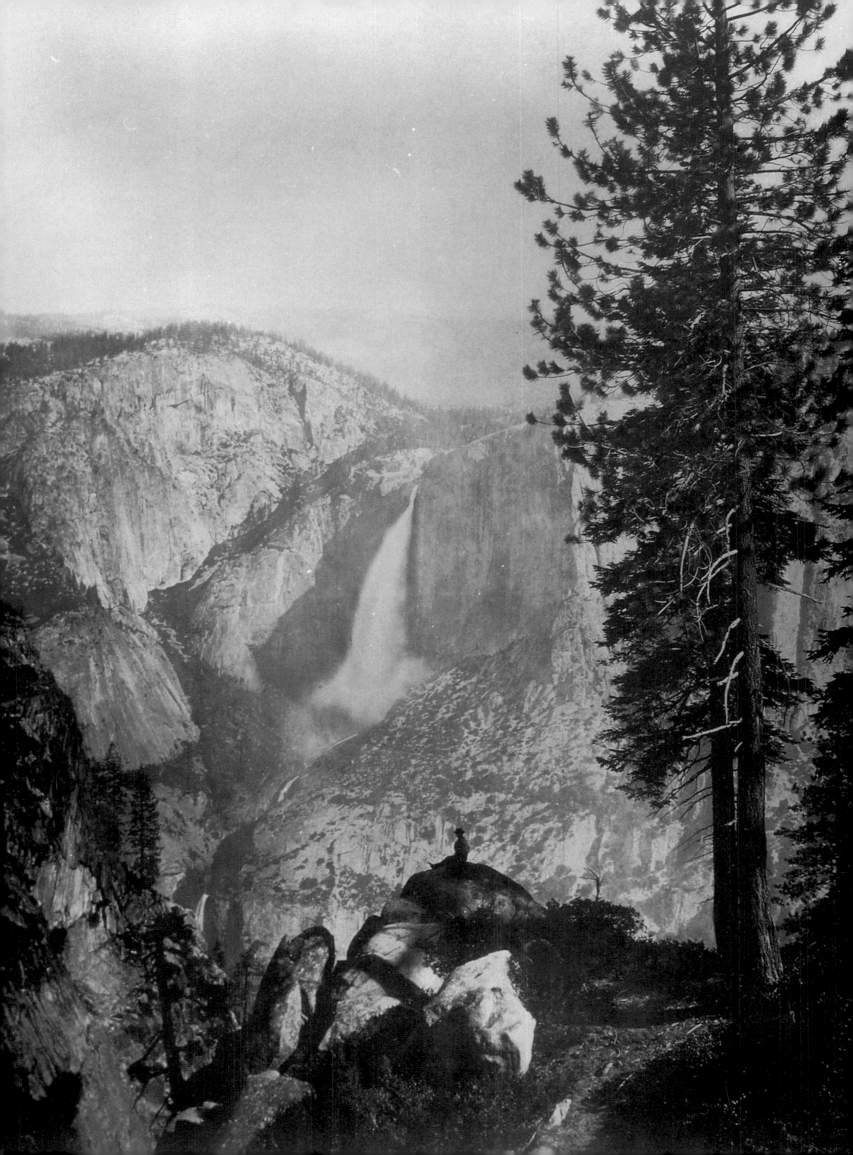

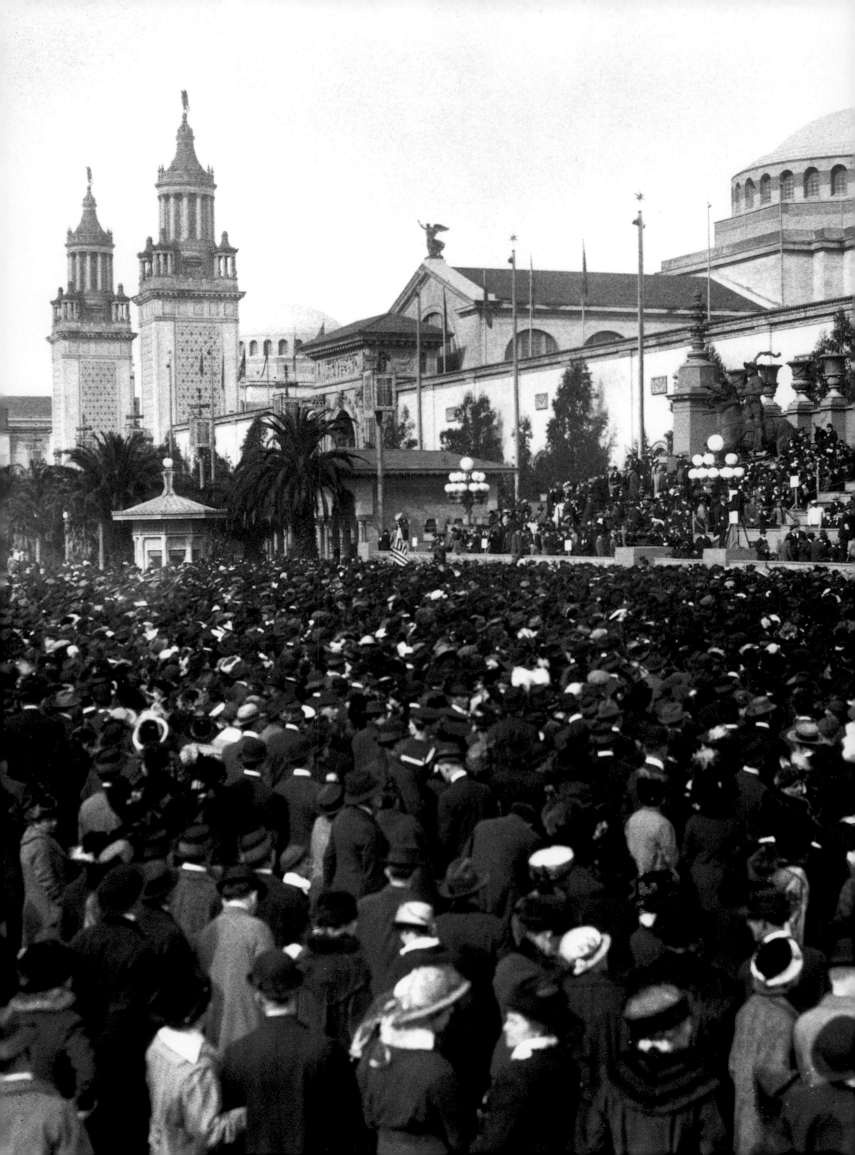

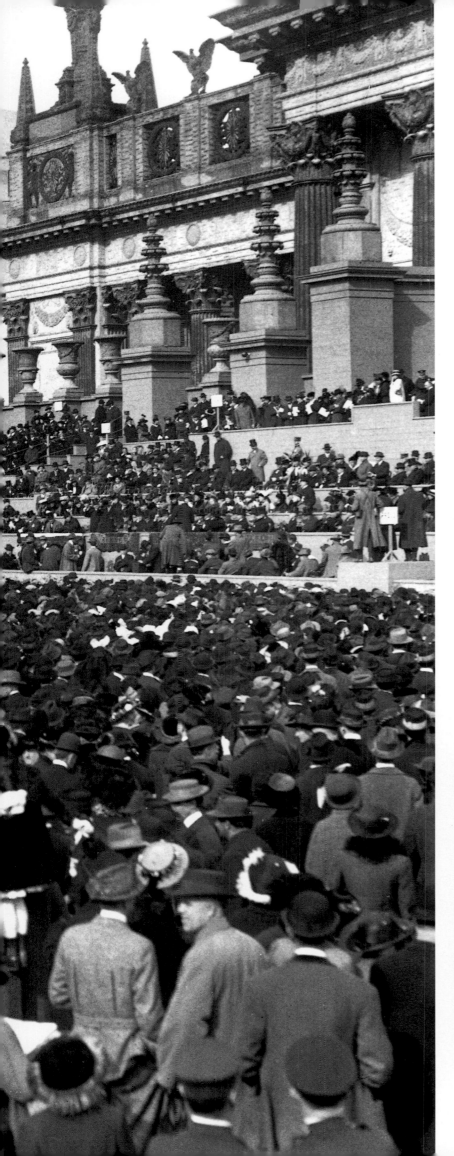

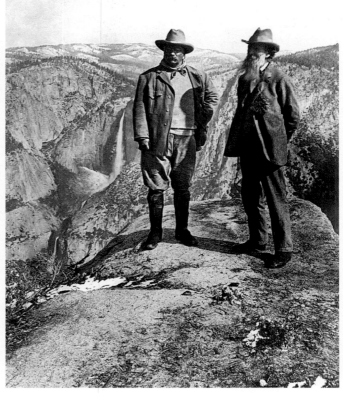

LEFT: *The opening ceremony of the Panama-Pacific International Exposition held in San Francisco in 1915. Adams attended this fair with his father and was impressed by the paintings of Gauguin, Monet and Cezanne.*

BELOW: *The founder of the Sierra Club, John Muir (right), with Theodore Roosevelt on Glacier Point above Yosemite Valley, California.*

his skills eventually developed to the level of concert pianist. There are elements of his prints that have a musical appeal, when he records the natural rhythms of a landscape, or when his lens captures a triumphant perspective of a natural treasure of the West.

But when he was 14, two events occurred which redirected his future. His father gave him his first camera, a Brownie Box model by Kodak, and in the summer of 1916 the family embarked on a vacation to the Yosemite Valley. Seeing its mountains and lakes for the first time was a moment of epiphany for Adams and he savored its beauty. He would later live there year-round and he would continue to visit every year throughout his lifetime.

Upon graduation from high school Adams worked as an apprentice for a photo finishing company for two years. Following this, he was a custodian for the Sierra Club in Yosemite National Park, a position far better suited to his wanderlust. While on the job, he took photographs of the region, which he developed by printing the negatives in buckets of water brought from the mountain lakes to the club's LeComte Memorial Lodge.

Adams' ambition to portray Yosemite was in concert with the aims of the Sierra Club's founder, John Muir. Muir created the organization in 1892, in the interest of defending wilderness territories from the encroachment of development. As the club's executive director, David Brower, wrote in 1965, "We give high priority to wilderness because it is the most fragile resource: man can destroy but not create it."

The Sierra Club was organized as a nonprofit, public trust devoted to the study and protection of national parks and wilderness regions.

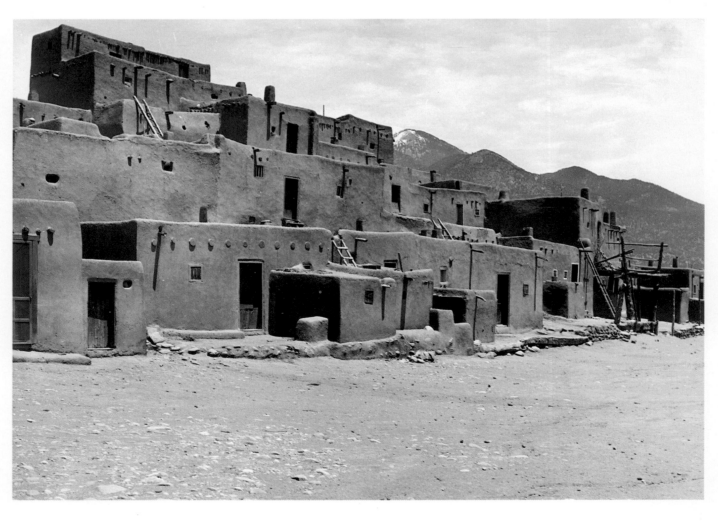

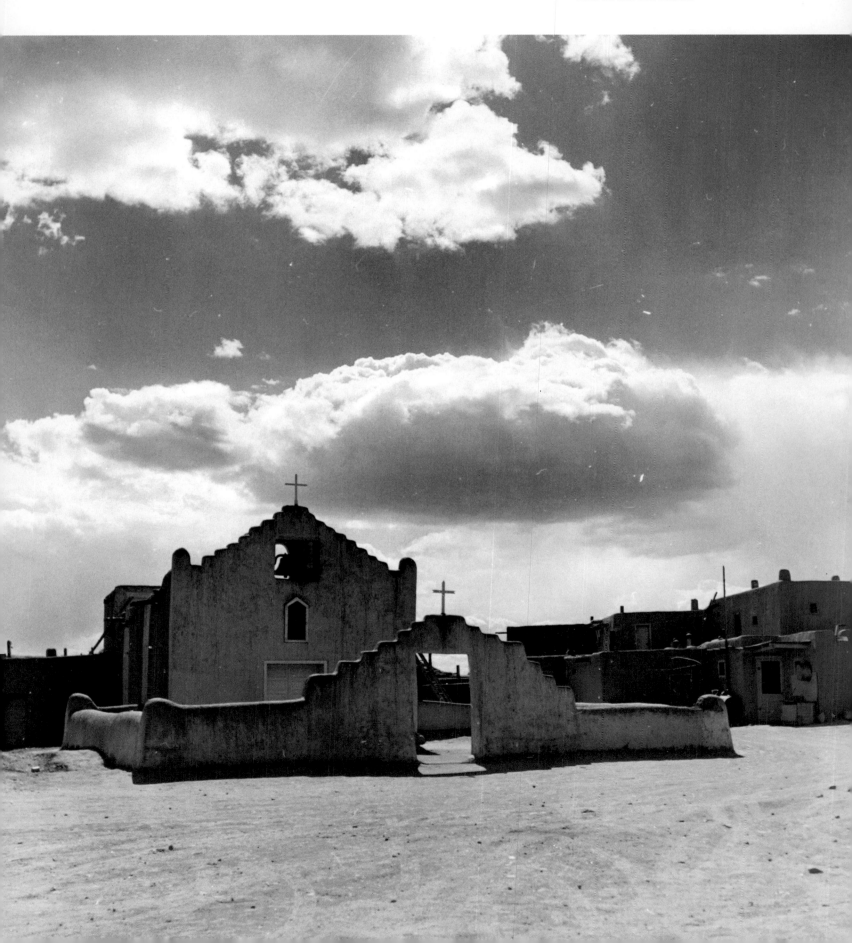

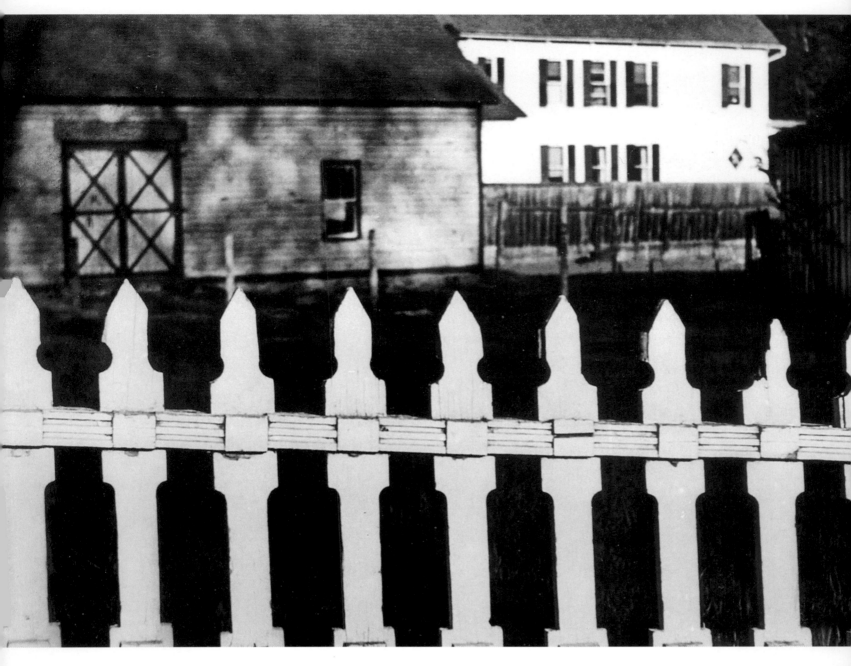

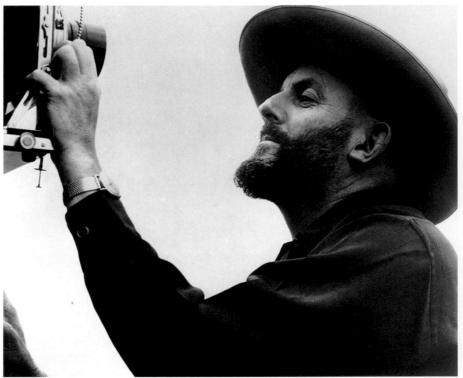

ABOVE: *In Taos, Adams met Paul Strand, a photographer who became his mentor. Here is one of Strand's photographs, "The White Fence, Port Kent, 1916."*

RIGHT: *Ansel Adams adjusting his lens. Sharpness and detail were very important elements of Adams' photography.*

A guiding tenet of the Sierra Club's membership is that those who know a place well can best defend it. Its directors and board members enlist public assistance, including the Department of the Interior, the Forest Service and the Division of Highways, to make wilderness areas as free as possible from man's intrusion and technological development.

A primary goal is to promote legislation to preserve the variety and well-being of nature's flora and fauna because "other creatures have a right to a place in the sun, whether or not men are there, but they have no standing in court and no vote with which to defend themselves against technology." The understanding is that man cannot live well without the beauty and wonder of the wilderness and its creatures.

During the early 1920s Adams acted as a guide on Sierra Club mountaineering trips and led faculty members from Stanford and Berkeley through various parks and ranges. His photographs were printed in regular editions of the Sierra Club's bulletin, giving him some measure of public recognition. He continued to play the piano as well, often at the home of his friend, Harry Best, who owned the Best Photographic Studio in Yosemite. Adams later married Harry's daughter, Virginia Best in 1928.

One of Adams' first significant patrons was Albert Bender, a wealthy man interested in the arts, who also hailed from the San Francisco Bay area. Together they traveled through the Taos, New Mexico, region where Adams took extensive photographs which were published in his book, *Taos Pueblo*, in 1930. This first edition of only 100 books sold for $75 apiece. By the mid-1980s, their value was estimated at $12,000 per copy.

This is not an extraordinary increase in comparison with paintings by American masters such as Winslow Homer or John Singer Sargent, but it should be noted that each of their paintings was an original.

In Taos, Adams joined a coterie of artists and photographers who gravitated to the home of the automobile heiress, Mabel Dodge Luhan. At her ranch Adams met the painter Georgia O'Keeffe and the man who would become his mentor, Paul Strand. Strand was the catalyst for Adams' decision to pursue photography as a career. Strand's photographic images were composed of strong contrasts of light and dark combined with a heightened sensitivity to scale. In his 1915 print "New York (Wall Street)" pedestrians appear tiny next to the monumental array of darkened skyscraper windows. Adams would apply this same strategy to subjects in nature, cropping the negatives where necessary for visual impact in the finished work. However, as his experience and expertise developed, he could anticipate the outcome prior to shooting on location.

The synergy of the Taos artists' styles and imaginations is particularly evident in the series of photographs Adams shot in the foothills and pueblos of New Mexico. His images of the churches in Taos — close-ups emphasizing pueblo architectural forms employed by Indian tribes that appear wonderfully straightforward to the modern eye which is satiated with rococo excess — are quite similar to prints by Paul Strand and oil canvases by Georgia O'Keeffe.

What these artists discovered in New Mexico was the implicit grace of simplicity that the native Indians understood by virtue of their familiarity with the desert territories and their

sustainable lifestyle. The spiritual elements of these rough adobe huts have resonated across the vast domains beyond them and through the course of centuries.

Adams' technical strategy of deepening the shadows of the pueblos' recesses and accenting the sunlit cliffs was achieved by adding a special green filter to his lens. The quality of the lighting in his image of Walpi is superbly gradated so that the rugged ruins become a shining fortress on a hill.

Adams was also attuned to the particular conditions present in nature that would contribute to a dynamic photograph. He preferred Yosemite in the wintertime when the whiteness of snow-flecked glaciers and peaks was juxtaposed with jagged, shadowy cliffs and eaves of snow weighed upon slender branches of aspen. During the 1960s when Adams traveled frequently by automobile in search of arresting vistas, he directed a friend to stop the car at dusk in Hernandez, New Mexico, to catch the full moon rising over the tiny, hillside village. Its ebony evening sky offered a backdrop to ghostly details of cemetery crosses lit by the setting sun.

Adams never tired in his ardor for the Western landscape. "It's inevitable for me to take these pictures. It's there, I feel great excitement and I take the picture." And although he had a refined awareness of the camera's technical possibilities, it is his passion for mountain ranges like the Sierra Nevada that is so compelling. The critic James Agee remarked that the essential aspect of camera work is "what is in the eye, mind, spirit and skill of its operators."

Adams often waited for weeks or even months to capture an image at its zenith, when the light and atmosphere revealed unique features of a site. On occasion he set up camp at night, placed his 8" x 10" view camera in a particular spot and went to sleep in a sleeping bag laid out on a platform he built on top of an old Cadillac. He would set his alarm for the first light of dawn, and would rise to take the photograph. In his later years Adams traded the dusty old Cadillac for a station wagon specially mounted on a truck chassis equipped with a large camera and special compartments to store his gear.

Adams used his 8" x 10" view camera to make large, sharp prints of landscape vistas. In addition he employed his 2 1/2" x 2 1/4" Hasselblad for a variety of assignments and a 35 millimeter Zeiss Contarex for portraits of people. For images of architecture and scenes where camera adjustments were essential, he used a 4" x 5" Arca-Swiss.

Occasionally, to eliminate any fuzziness in the 8" x 10" view camera prints, he would replace its ordinary lens with a small metal disc with a pinhole opening 1/50 of an inch in diameter. Only a few rays of light reflected from the subject could get through the opening and these struck the film in such minute clusters that blurring was reduced to a minimum. Crisp details of mountain peaks, running fence lines or rooftop interstices could prevail.

Adams felt a deep respect for the inherent drama of his subjects. "Some photographers take reality as the sculptors take wood or stone and upon it impose the domination of their own thought and spirit." He hoped his photographs would be considered as "ends in themselves, images of the endless moments of the world."

In 1930 Adams returned to the San

RIGHT: *Georgia O'Keeffe, at an exhibition of her work* Life and Death *in 1931. Adams met O'Keeffe in Taos in 1927 and they remained friends throughout their lives.*

BELOW: *Edward Weston was one of the original members of Adams' photography association f/64. Here Weston is seated at an exhibit of his work at the Museum of Modern Art.*

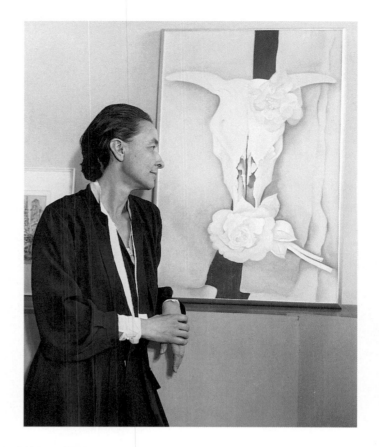

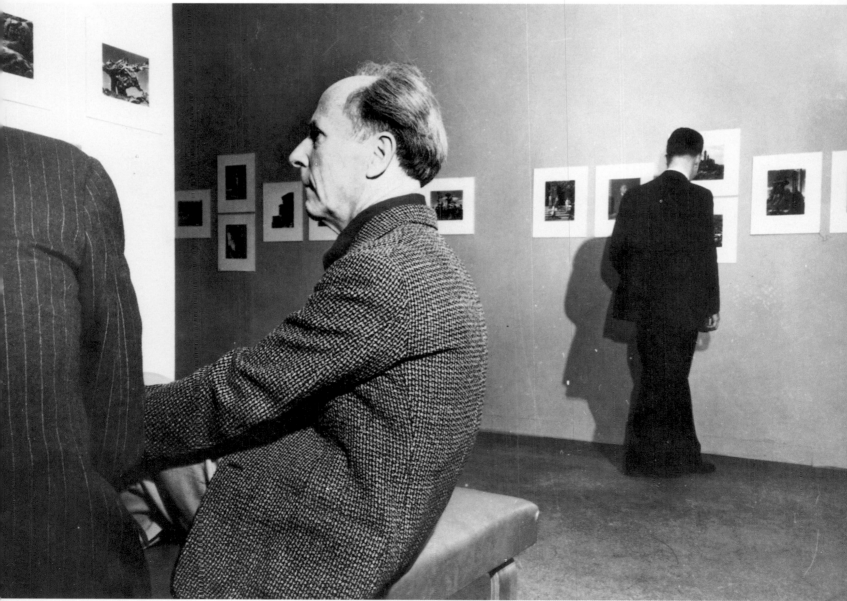

Adams' photograph "Walpi, Arizona, 1941." The magnificent lighting that Adams captured makes the village seem like a shining fortress on a hill.

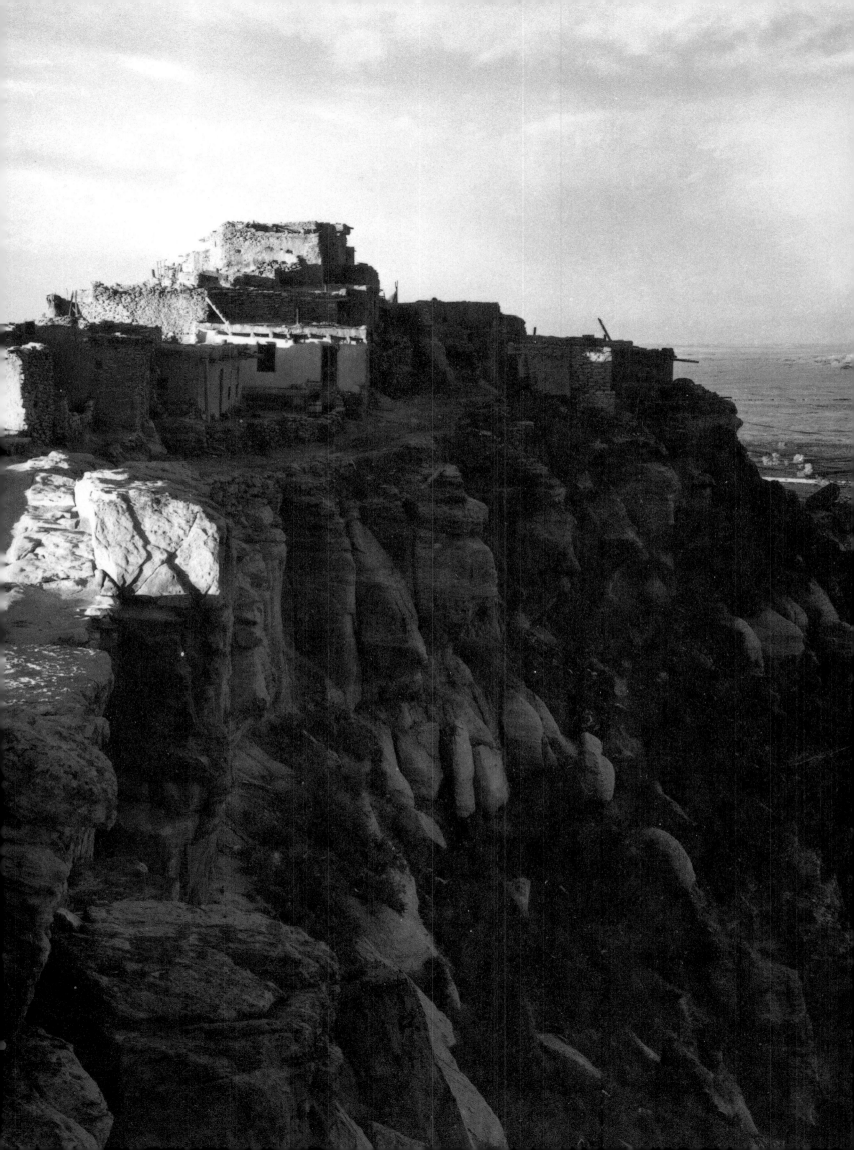

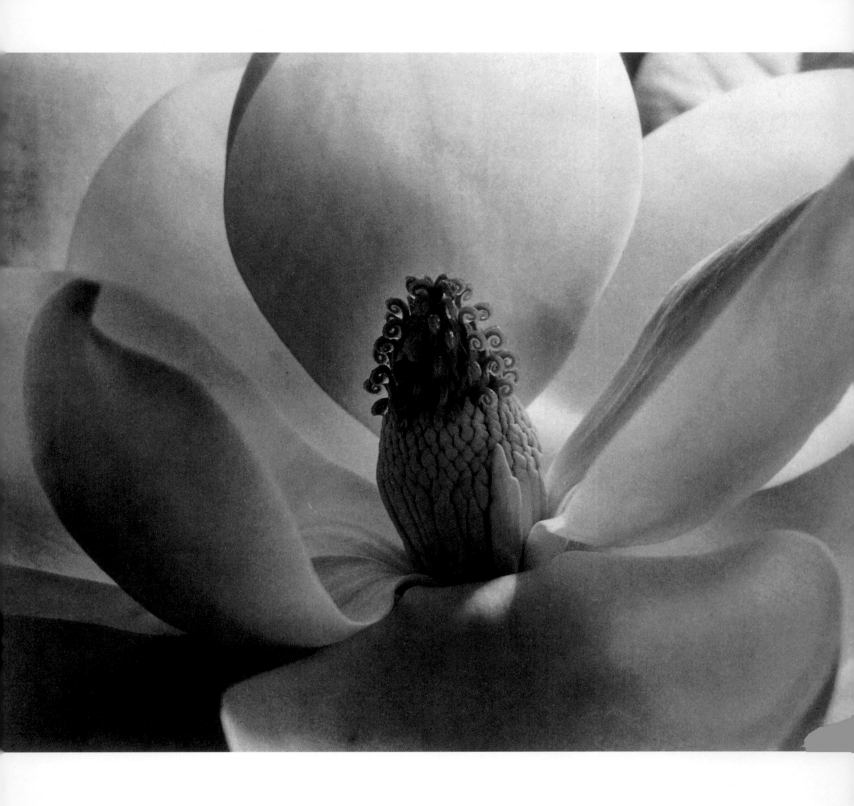

Another member of f/64 was Imogene Cunningham. Cunningham focused almost exclusively on portaits and close-ups of flowers and objects. Here is her "Magnolia Blossom, 1925."

Francisco area, built a new home and studio, and began advertising for commercial assignments. Although best known today for his black and white photographs, Adams used color film for his commercial clients — an impressive roster that included Pacific Gas and Electric, Hills Brothers Coffee, AT&T, Eastman Kodak, The American Trust, and his most significant patron, the Yosemite Park and Curry Company.

He also wrote reviews for a photography magazine, *The Fortnightly*, promoting his fellow artists Eugene Atget and Edward Weston. He and Weston would later work together frequently on behalf of the Sierra Club and became good friends. Their photos often seem interchangeable, a result of their close relationship and shared techniques.

The 1930s were a productive decade for Adams, a time when he formed valuable ties to important figures on the East Coast who would enhance his career. His family flourished as well, beginning with the birth of his first son, Michael in 1932. In 1934 he established a photography collective called "f/64", referring to the smallest aperture setting on a camera, 64, that allows for the greatest sharpness of detail. This clarity described the members' art which had a sleekness and purity akin to the streamlined architecture of the era, as well as to Art Deco furnishing and many of the new abstract paintings. Among the members were Imogene Cunningham and Edward Weston.

It is interesting to note the variety of work developed by members of the f/64 group. In contrast to Adams, Imogene Cunningham focused almost exclusively on portraits of people and close-ups of flowers and objects. Her eye was exquisitely sensitive to nuances of character and line. Cunningham also made some studies of nudes whose formal contours are echoed in images of bell peppers viewed in close-ups by Edward Weston. Both photographers fill the print space with their subject and the shapes appear as solid and smooth as marble sculpture. Weston wrote in his diary, "Completely satisfying — a pepper — but more than a pepper: abstract, in that it is completely outside subject matter."

Adams and Weston had a common interest in the abstract possibilities of natural phenomena: swirling patterns of rock outcropping, the linear shapes of driftwood and tree limbs, the architecture of cliffs, the shadows and currents of lakes and surf. Both were masters of clarity and high contrast, elements that lend a sense of purity to wilderness domains.

Though the f/64 group proclaimed photography as a unique art form, several compositional features link their work to the other media of the time. However, the members printed their 8" x 10" negatives, made with view cameras, on glossy paper in an effort to avoid textural qualities that would seem to imitate brush painting and so establish photography as a unique art form. In light of more recent vogues such as photo realism and pop art which often seek to copy the camera's eye, the desire to distinguish between and separate various art forms seems surprising. Yet at the time, Adams and his cohorts were determined to gain public recognition for their craft and succeeded.

In the early 1930s the center of photography was in New York at Alfred Stieglitz's gallery The American Place, known affectionately as "The Place." Adams traveled to New York in 1933 for

an exhibit of his work held at the Delphic Studios and he took some of his prints to Stieglitz for a critique. Stieglitz's response was positive and highly encouraging, propelling Adams to pursue photography as the modern muse. Three years later he would return for a one-man show at The Place, a sign of his acceptance into the hallowed circle of the contemporary art world.

In 1934 Adams was elected to the board of the Sierra Club and in 1936 he traveled to Washington, DC, to lobby for a new park site at Kings River Canyon in California. Since its inception the Sierra Club has enlisted the participation of artists, photographers, writers and poets to promote its aims before government legislators. In 1864, Carleton Watkins' pictures of the Yosemite Valley helped to establish the park that Adams loved so well. Photographs by William Henry Jackson influenced congressional leaders to create America's first national park in 1872 at Yellowstone. Their legacy had now been handed down to a new generation and Adams embraced the cause of conservation.

When Adams returned West, he and Virginia decided to settle in Yosemite. Her father Harry had died leaving the future of the Best Studio to their management, and with their direction it would flourish for fifty more years. Their home and studio was Adams' base of operations, yet he continued to travel often.

By 1940 photography had improved technically and artistically and its partisans sought parity with the other fine arts represented in national museums. Adams was an ardent apostle for the medium and he was very well-versed in its technical aspects. When the Museum of Modern Art created a Department of Photography in 1940,

Adams was called back to New York to serve as a special advisor for six months. David McAlpin, a businessman and art patron, chaired the Photography Committee and Nancy Newhall, an art historian and friend of Adams', was named the department's first curator. Adams and Newhall later collaborated on the design of the exhibit-format series of books published by the Sierra Club that combined photographs, poems and prose in support of conservation and the national park regions. The books proved to be enormously popular, especially in paperback form, and helped to proselytize new devotees to the cause of the environment.

The first photography exhibit at the MoMA, "Sixty Photographs," opened December 31, 1940. It included a range of work spanning from the 1840s to that of modern stylists such as Adams, Edward Weston, Paul Strand and Alfred Stieglitz. Upon his return to the West Coast, Adams taught a photography course at the Art Center School in Los Angeles where he invented the Zone System, a technical device to determine and control contrasts of light and dark within a black-and-white print. Adams felt that the careful measure of contrast was necessary to make images more striking. He divided the range of light into eleven tones (or zones) over a spectrum from black (zero) to white (10). Adams acknowledged that the system was quantitative rather than a means to express passion or insight, and he also stressed individual perception as the most important key to artistic value. Technical proficiency was intended only to parallel and assist personal visions.

At 41 and married with children, Adams was unfit to serve in the armed forces during World

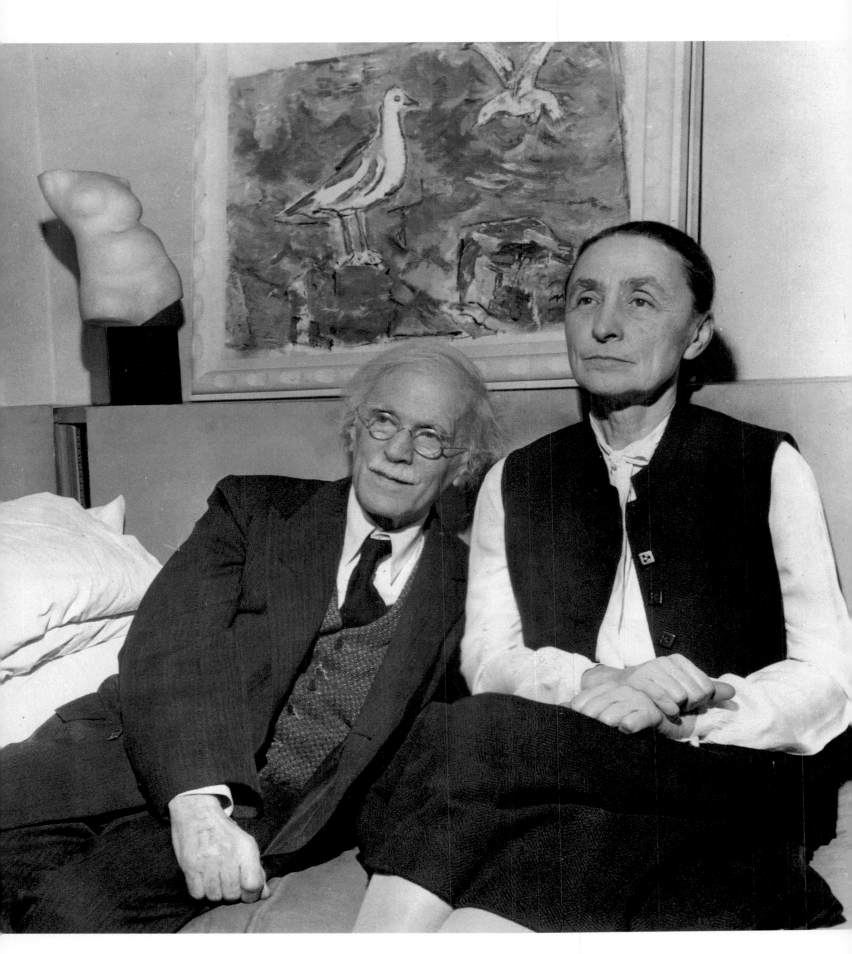

Georgia O'Keeffe with her husband Alfred Stieglitz, an influential photographer in New York who encouraged Adams in his photography career.

BELOW: *Adams traveled through the rugged desert of New Mexico taking photographs for the Department of the Interior's Mural Project in the late 1930s.*

OPPOSITE: *William Henry Jackson helped influence congressional leaders to establish Yellowstone National Park with his photographs, including this one, "Mammoth Hot Springs, Yellowstone, 1872." Later, Adams used his photos to aid the Sierra Club with its conservation efforts.*

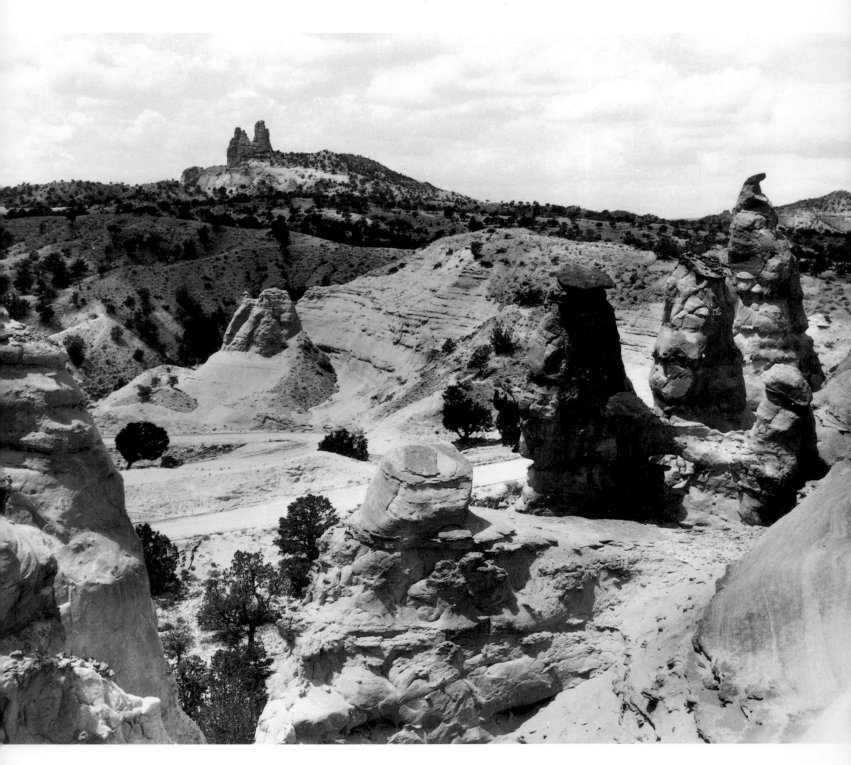

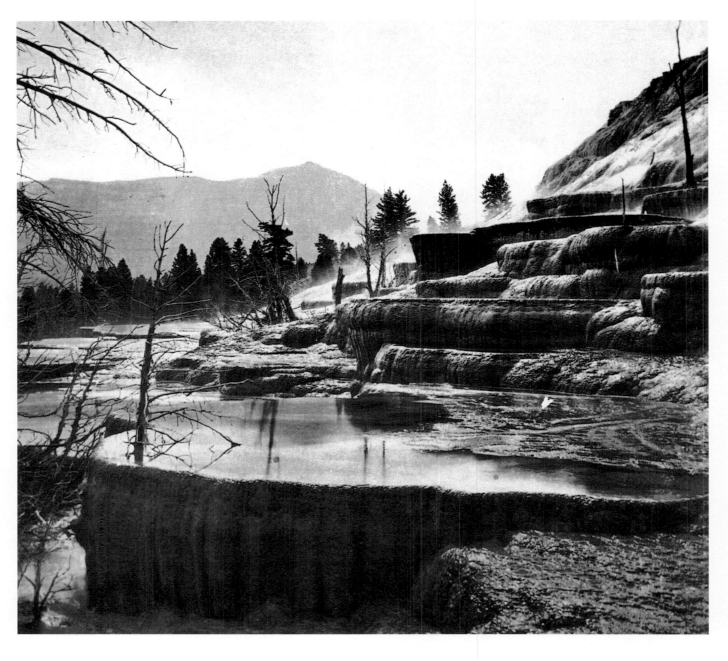

War II but he escorted American troops around Yosemite Park. He later was hired by the director of a Japanese prisoner-of-war camp in Owens Valley, California, to document the lives of the people there. His book, *Born Free and Equal*, published in 1944, is a testimony to the bravery and dignity of the Japanese-American citizens who were taken from their homes and held captive 300 miles north of Los Angeles. It also details the physical beauty of the region, for Adams at heart preferred documenting landscapes to human struggles.

During the late 1930s and early 1940s, Adams received a project initiated by Harold Ickes, the Secretary of the Interior, to document the beauty of the West and display mural-sized photographs of its canyons, lakes and mountains in the Washington office of the Department of the Interior.

Adams took his eight year-old son, Michael, with him on this project as well as his close friend, Cedric Wright, and the trio traveled the back roads of New Mexico discovering the desert. Adams continued into the Rockies on his own by railroad and by car. The sites Adams photographed were far easier to reach in the twentieth century because of the automobile, but nature would occasionally intervene and assert its

dominion — during one rainy season, it took Adams 15 hours to travel 60 miles over mud holes and washed-out ravines.

Adams also traveled to Arizona, where he photographed the astonishing breadth of the Grand Canyon which is as powerful to behold today as it must have been to native settlers. Rock formations a mile high rise up from its floor and it extends 18 miles from one side to the other at its widest points. Here Adams discovered the seductive emptiness of the West, a place where art and ideas could develop in the midst of a spell-binding solitude.

One of the most striking vistas Adams shot during the Mural Project tour is the incandescent, undulating print of the Snake River gliding past snow-capped peaks in Grand Teton National Park in Wyoming. The sun is banked behind dark cumulus clouds, but its rays highlight the vertiginous mountains and reflect the s-curve of the river, slinking like a desert rattlesnake through the valley below.

The Mural Project was abandoned in 1942 because of World War II, but Adams' work for the Department of the Interior enabled him to secure two successive Guggenheim fellowships in 1946 and 1948. New technology in his field made his work far more accessible to a broader segment of the population. By 1950, he had traversed most of the nation's existing parklands, trekking as far north as America's last great wilderness territory — Alaska.

Weather conditions in Alaska presented formidable obstacles to a photographer traveling by land or by plane — Adams often flew in small propeller planes to reach remote regions. When torrential rains prevented pilots from flying,

Adams took a series of close-ups of ferns and lichens in the region of Glacier Bay, an inlet in the southeastern Gulf of Alaska where a park had been established in 1925. Adams' close-up photographs were different from his parkland vistas. Here the emphasis was on pattern and compositional details and the delicate structures of plant life.

The sense of nature's glory and man's freedom in wilderness realms was more profound in Alaska because of its size and relative liberty from development of any kind, even as late as the 1940s. Adams had long perceived a spiritual dimension in virgin forest and heroic mountain ranges, one that Robinson Jeffers alluded to in these lines from his poem, "Shine Republic:"

The quality of these trees, green height;
of the sky, shining, of water, a clear flow;
of the rock, hardness
And reticence; each is noble in its quality.
The love of freedom has been the quality of
Western man.

Adams' 1947 perspectives of the Teklanika River in Alaska's Denali National Park share the horizontal sweep of Sydney Laurence's 1924 painting of Mt. McKinley. Yet there is a distinct difference — where Laurence's soft pink and blue atmospheric effects lend the setting a romantic allure, Adams' graphic, churning, black-and-white print of the river surface reveals both the power and the coldness of the locale. The peaks in the distance are lovely but the rigors of reaching them are readily apparent.

Following his sojourn in Alaska and a subsequent visit to Mt. Rainier in Washington State, Adams felt renewed determination to produce a

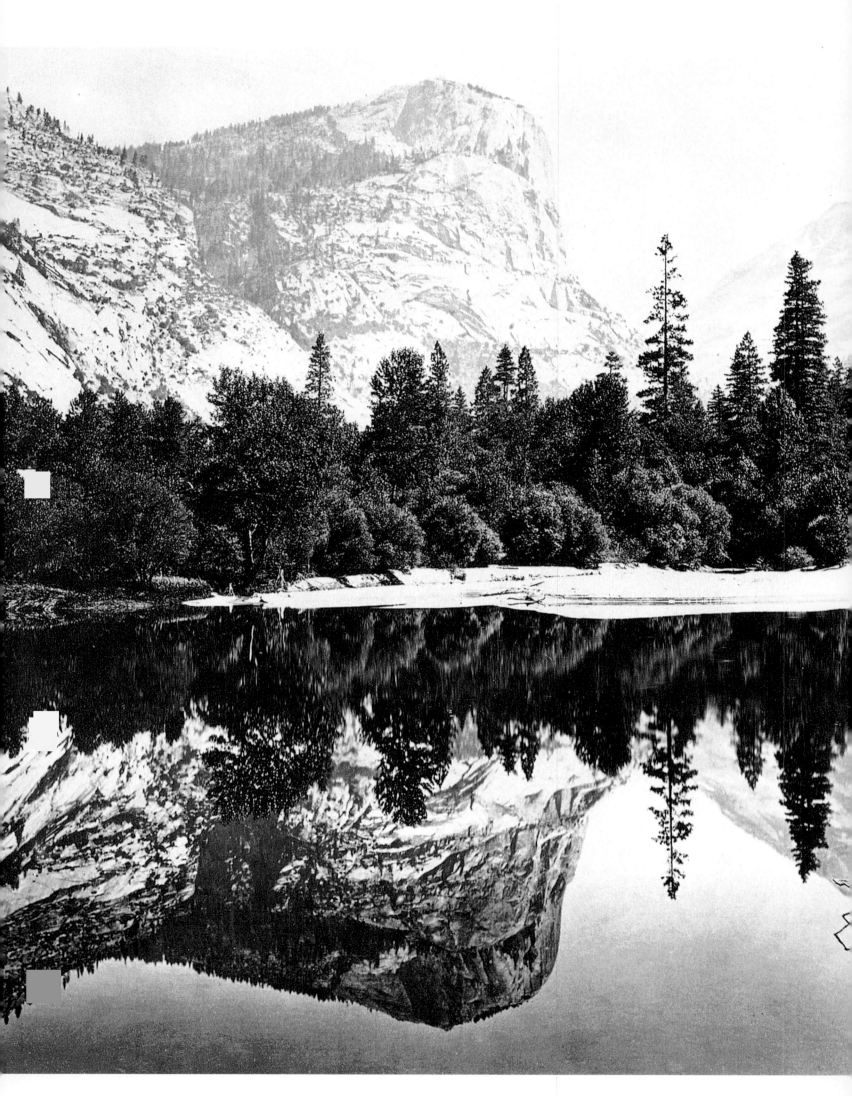

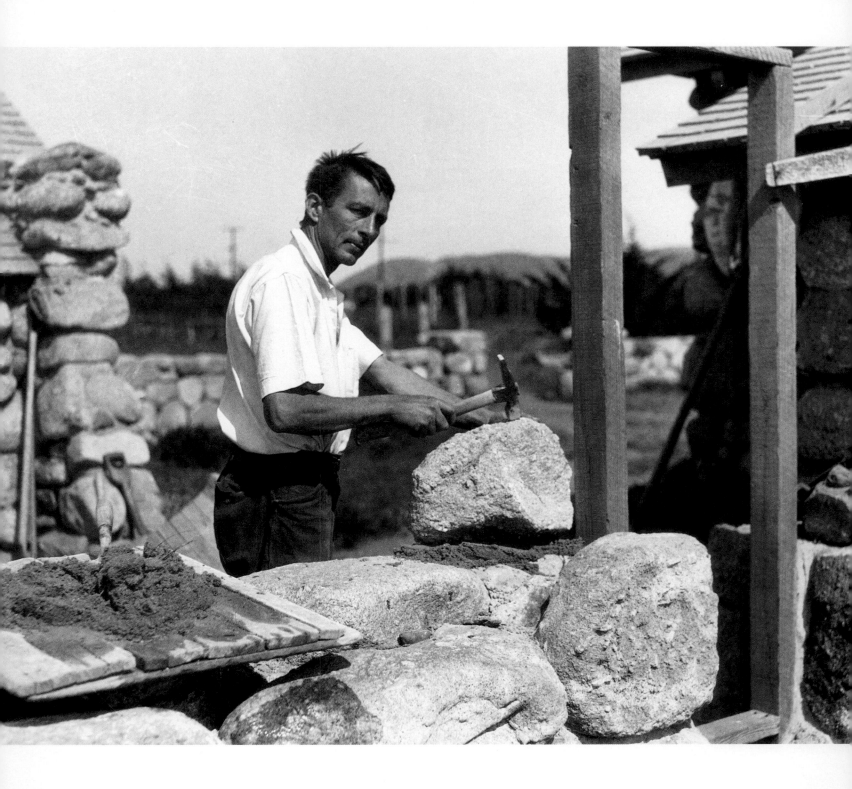

PREVIOUS PAGE: *Carleton Watkins'*
"Mirror Lake, Yosemite, No. 75, 1878"
was used to illustrate the natural wonders
of Yosemite to Congress and helped to
establish it as a national park.

ABOVE: *Robinson Jeffers, an American*
poet, collaborated with Adams on many
Sierra Club projects which featured poetry
about nature illustrated by photographs.
Here he is building his castle in Carmel,
California, in 1926.

series of books that would encourage interest in the cause of conservation and America's parks. Alaska would prove to be a fertile resource in the future, both for designated "forever wild" regions and to oil companies eager to plumb deposits below its gulf waters and arctic bays. The struggle to balance preservation goals with economic ones is one of the state's great challenges of this century and the next.

Among the texts he published during the next decade were the final two volumes of his four-part "Basic Photo Series." He also created a magazine entitled *Aperture* with another modern photographer, Minor White. A friendship with Dr. Edwin Land, the inventor of the instant photo process, led to Adams' election to the board of the Polaroid Corporation, Land's business entity.

In 1955 Adams set up a teaching system at his Yosemite Studio called the Ansel Adams Workshops. He continued these programs when he moved back to Carmel, California. A primary goal was to enable students to anticipate the outcome of their photographs prior to shooting — a facility useful to save time, effort and film. Adams also sold many copies of his Yosemite Special Edition Prints to visitors to Best's Studio.

In 1962 Adams and his wife decided to resettle on the coast of California, where they had a gracious home built in the Carmel Highlands, specially equipped with a darkroom and a variety of amenities suited to Adams' profession.

Adams and Robinson Jeffers collaborated on a few projects including some for the Sierra Club. The Sierra Club was involved in the establishment of a network of scenic highways within the state and federal roadway systems to preserve the integrity of stretches of coastline and parkland. One such highway was Route 1 in California that travels alongside the Big Sur, a region dear to both Adams and Jeffers. Their collaborative work of poems and photographs was first published in a 1933 Sierra Club bulletin and blossomed over time in subsequent books and bulletins issued by the club.

In 1966 in collaboration with Edward Weston's son Cole, Adams formed the association "The Friends of Photography," a non-profit organization that drew international members interested in creative photography. Adams was the first president of its board of trustees and by the mid-1980s, under the resourceful directorship of James Alinder, the group grew to more than 12,000 participants.

One of the Friends' more challenging projects was an exhibit of Adams' work they displayed first in Shanghai, China, and later at the Beijing Museum of Art. Although relations between the United States and Chinese governments were strained at the time, Adams served as a cultural ambassador for the event, which drew 5,000 people a day and proved that art can transcend political barriers.

In honor of the association's endeavors, Adams decided to bequeath his home and studio to The Friends. He also founded the Center for Creative Photography in 1975 at the University of Arizona in Tucson and donated his archives of negatives. In 1977 he created a Curatorial Fellowship in the name of his good friends, Beaumont and Nancy Newhall, at the Museum of Modern Art. It was at the MoMA in 1974 and 1979 that two major retrospectives of his work were held.

In light of his efforts on behalf of the environment and in the field of photography, Adams was the recipient of many highly coveted awards in his later years. In 1966 he was elected a fellow of the American Academy of Arts and Sciences. In 1976 he journeyed to London for a full-scale exhibit of his work at the Victoria and Albert Museum. He was elected an honorary vice-president of the Sierra Club in 1978, despite discord that had earlier disrupted his relationship with the organization.

The dispute resulted from his disagreement with several members regarding the location of a nuclear power plant in the Diablo Canyon in northern Arizona. He opposed the selection of the Nipomo Dunes in favor of a region that later proved to be the site of a precarious fault. Adams was unaware of the fault's existence and the nuclear power company relocated the plant at his behest. Adams' pictures of the Nipomo Dunes are extraordinarily sensual with sinuous curves akin to the torso of a woman and sand that has the quality of smooth skin.

Other members of the Sierra Club opposed his commercial work for the Datsun automobile company because of the toxicity of automobile emissions and its effect on the ozone layer of the atmosphere. Adams felt that Datsun's more fuel efficient vehicles were preferable if not ideal and as ever, asserted his professional independence. His ardent lobbying for conservation in Washington, DC, continued unabated.

In 1979 President Jimmy Carter awarded Adams the Presidential Medal of Freedom and asked him to photograph the First Family for their official portrait, a unique honor he readily accepted, for he felt that Carter was a strong proponent of conservation legislation.

In 1981 Adams received the Hasselblad Medal in Sweden, an award named for the inventor of a camera that he often used and admired. Harvard University bestowed its Honorary Doctor of Fine Arts degree on him and the French awarded him their Legion of Merit, one of their highest civilian honors. To celebrate his eightieth birthday the concert pianist Vladimir Ashkenasy played for Ansel and Virginia Adams at their home in Carmel.

Adams suffered from heart problems in his last decade. He lived with a pacemaker for several years before succumbing to heart failure on April 22, 1984. Since his death, public recognition of his achievement has continued and his publications have thrived. The California Wilderness Bill, strongly supported by senators Pete Wilson and Alan Cranston, designated over 100,000 acres in the Sierra Nevada as the Ansel Adams Wilderness Area. Mt. Ansel Adams was officially named in the Yosemite National Park in 1985, as a tribute to a man who so loved the great peaks he dedicated his life to their inspiration.

I entered the life of the brown forest,
And the great life of the ancient peaks, the patience of stone,
I felt the changes in the veins
In the throat of the mountain,
 and, I was the stream
Draining the mountain wood; and I the stag drinking;
 And I was the stars
. . . each one the lord of his own summit

— Robinson Jeffers

30

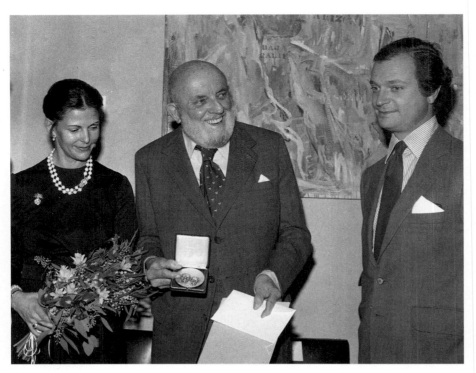

LEFT: *Adams accepting the Hasselblad Award from Sweden's King Carl XVI Gustaf and Queen Silvia in 1981.*

BELOW: *President Gerald Ford and his wife, Betty, selected one of Adams' photographs to hang above the fireplace in Ford's inner sanctum, a room off the Oval Office in the White House.*

NEXT PAGE: *Adams during an interview in 1982. Adams continued to work eight hours a day until his death two years later.*

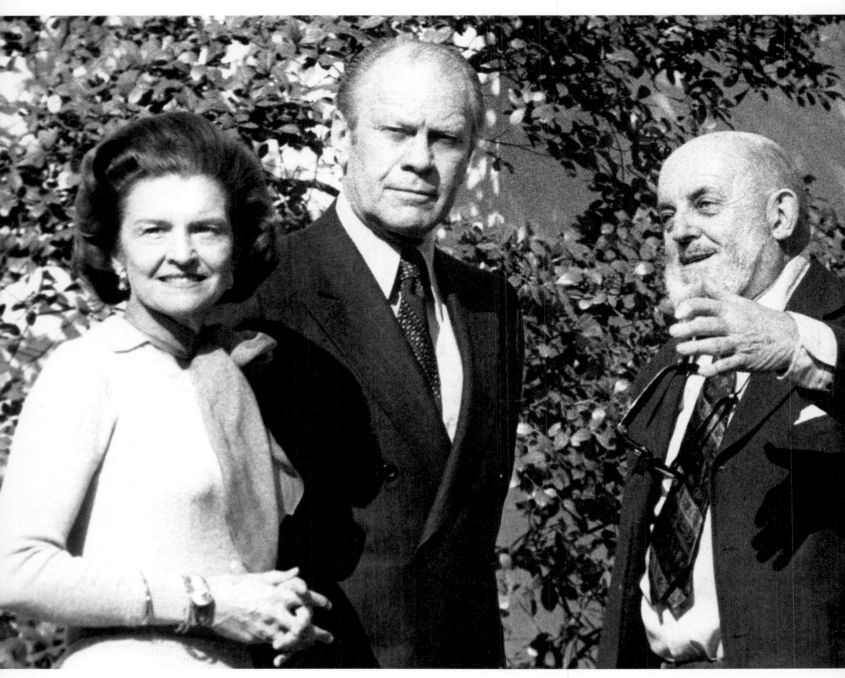

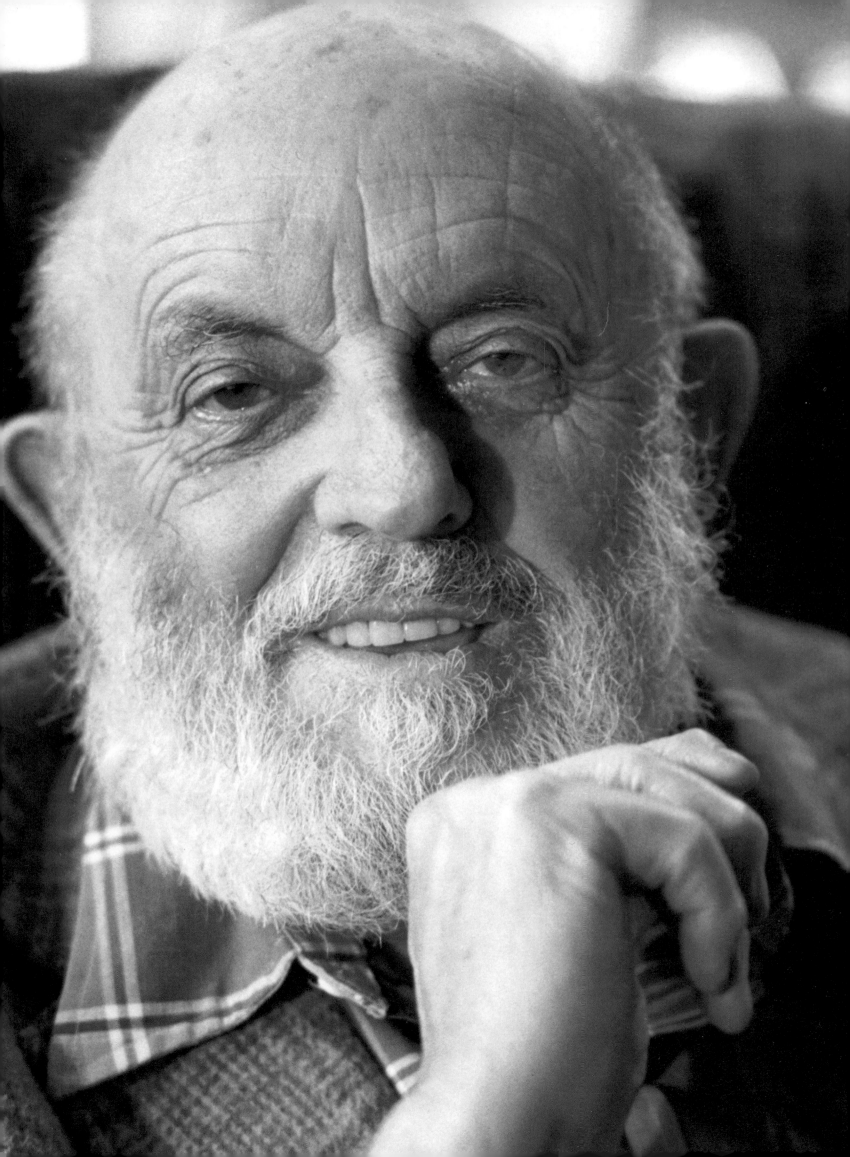

THE PLATES

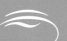

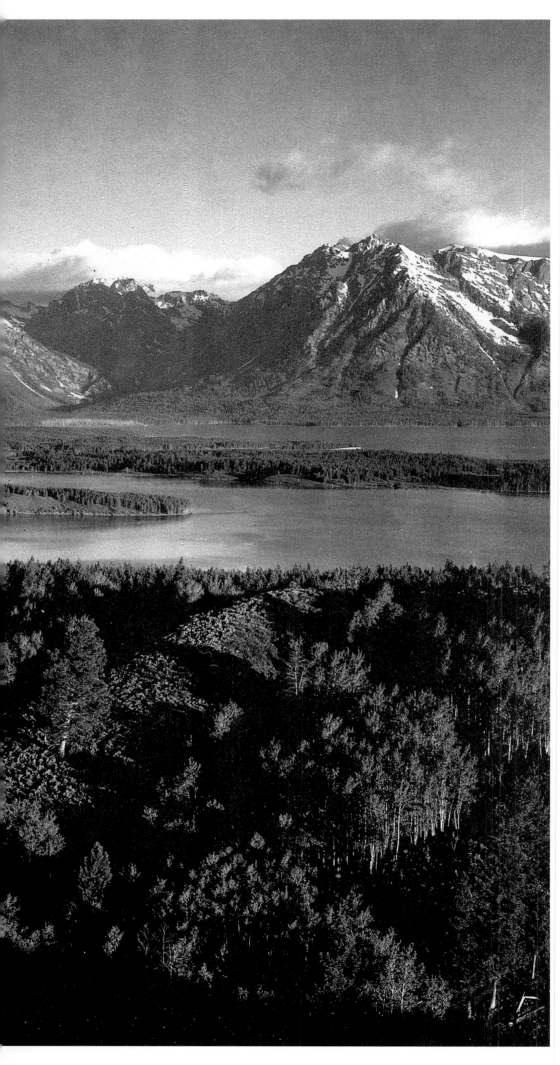

MT. MORAN AND JACKSON LAKE
FROM SIGNAL HILL
Grand Teton National Park, Wyoming

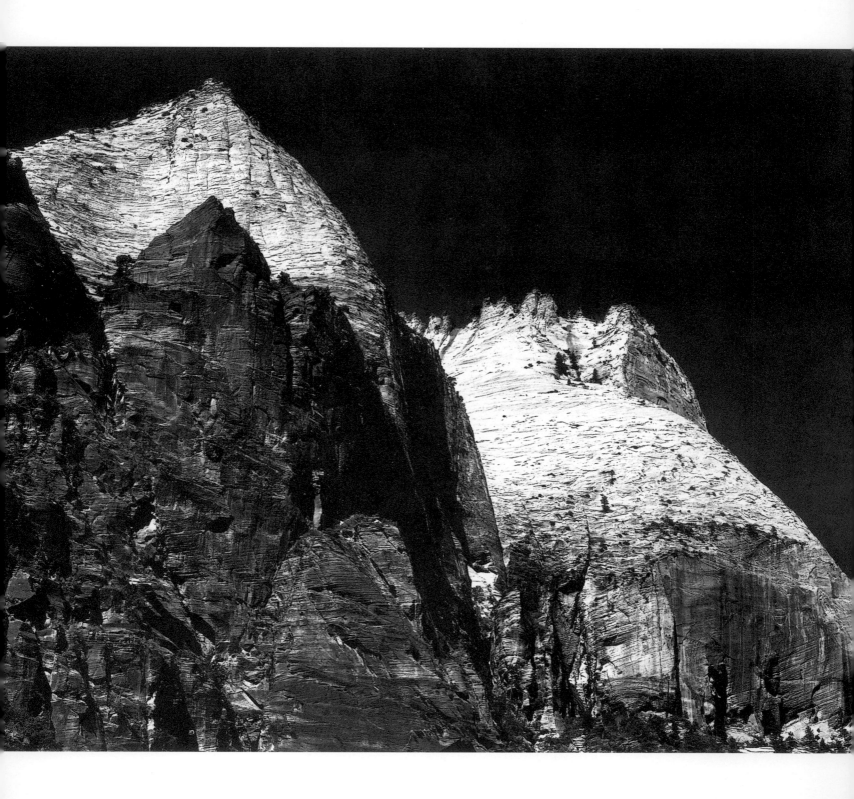

Above:
ZION NATIONAL PARK
Zion National Park, Utah

Opposite:
IN ROCKY MOUNTAIN NATIONAL PARK
Rocky Mountain National Park, Colorado

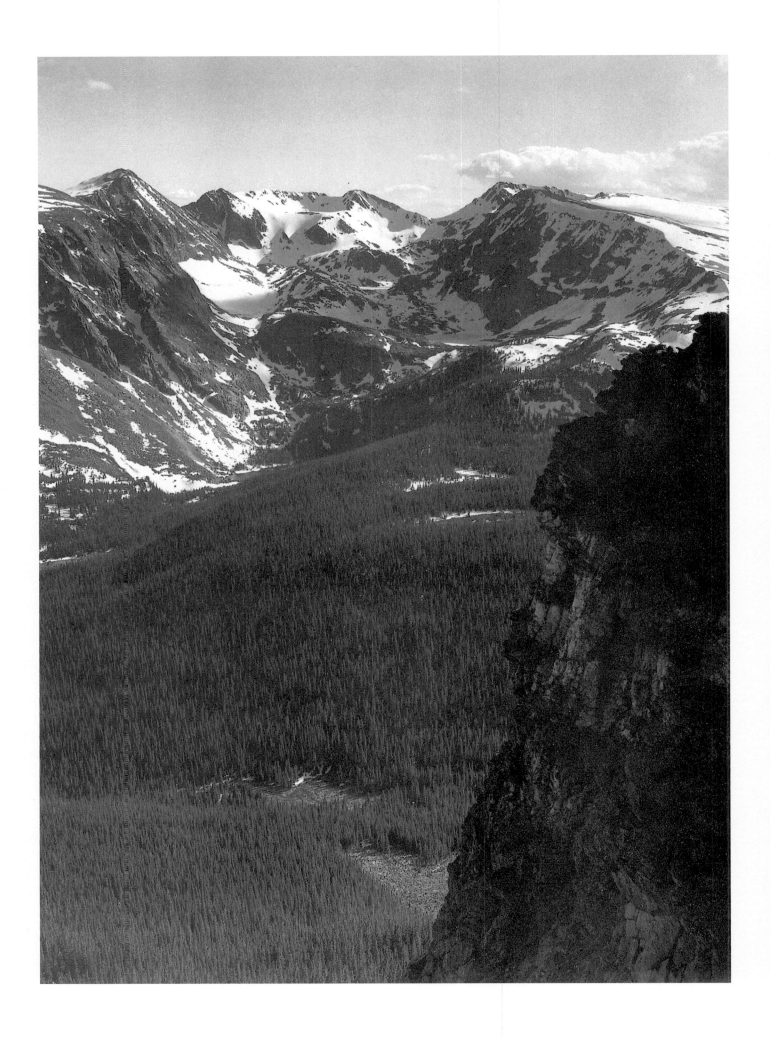

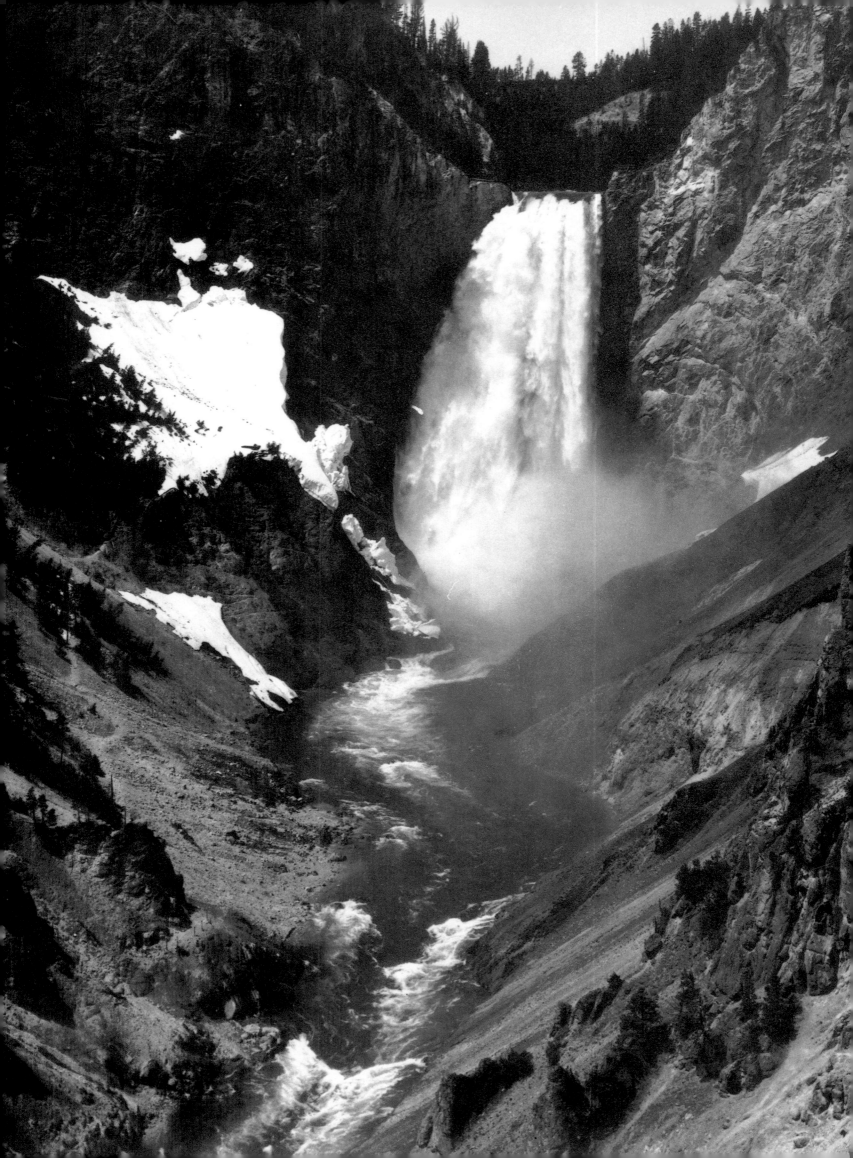

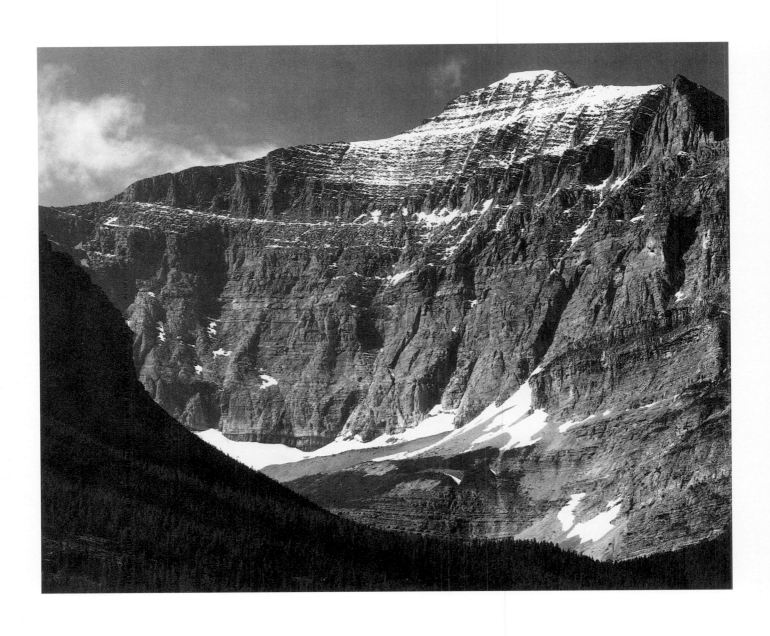

Opposite:
YELLOWSTONE FALLS
Yellowstone National Park, Wyoming

Above:
FROM GOING-TO-THE-SUN CHALET
Glacier National Park, Montana

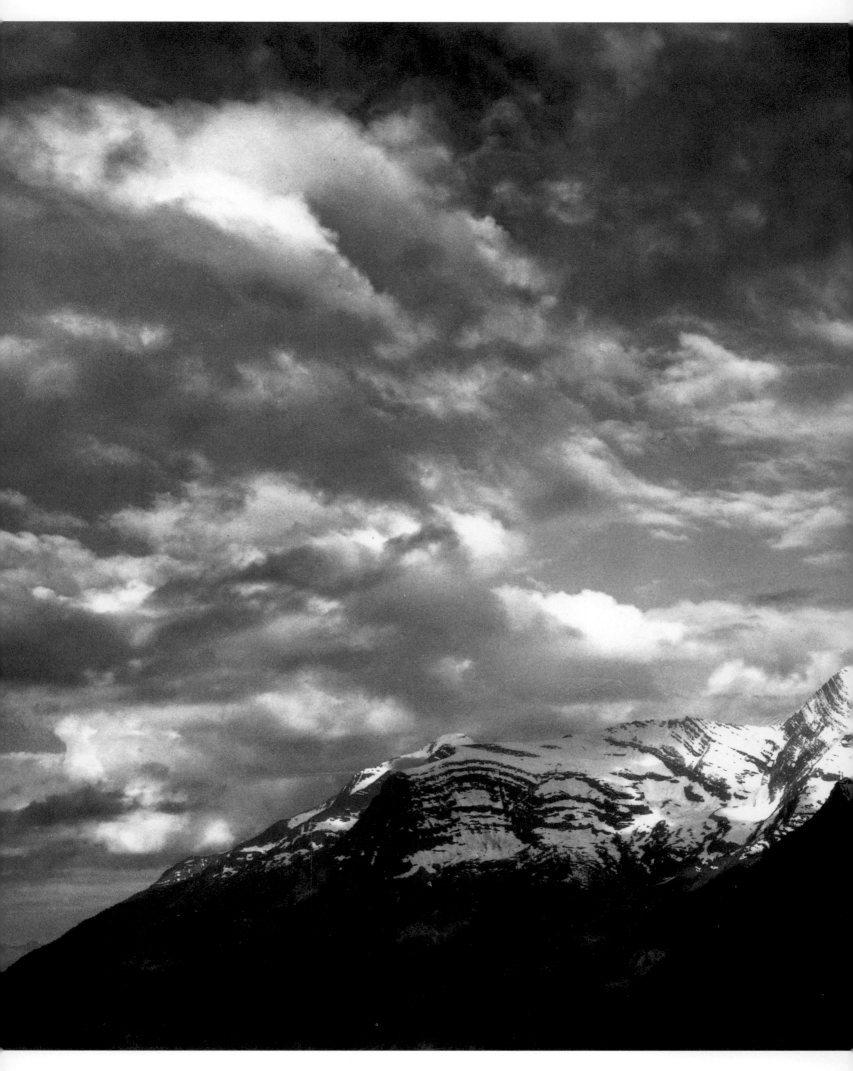

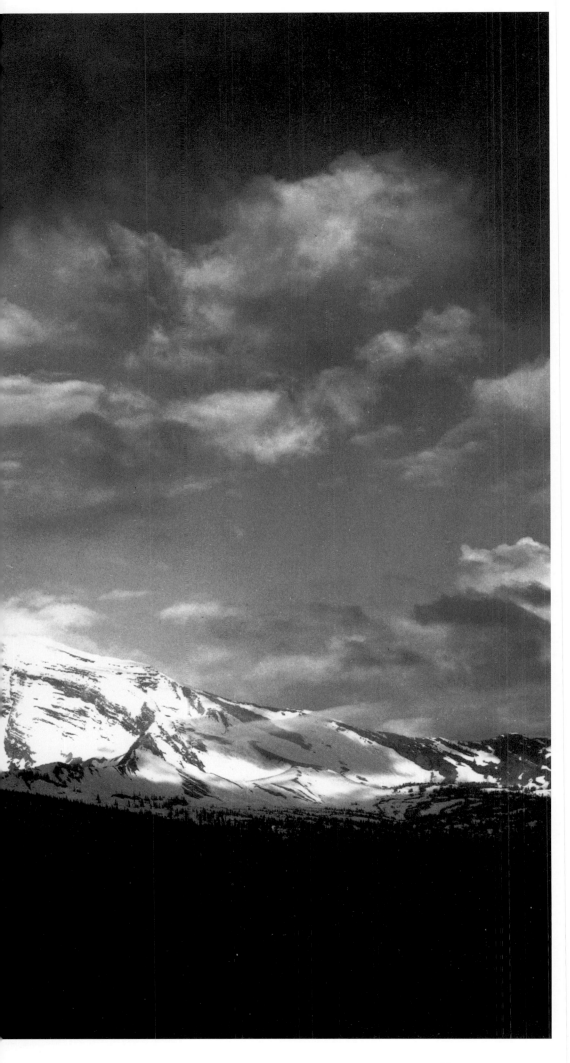

HEAVEN'S PEAK
Glacier National Park, Montana

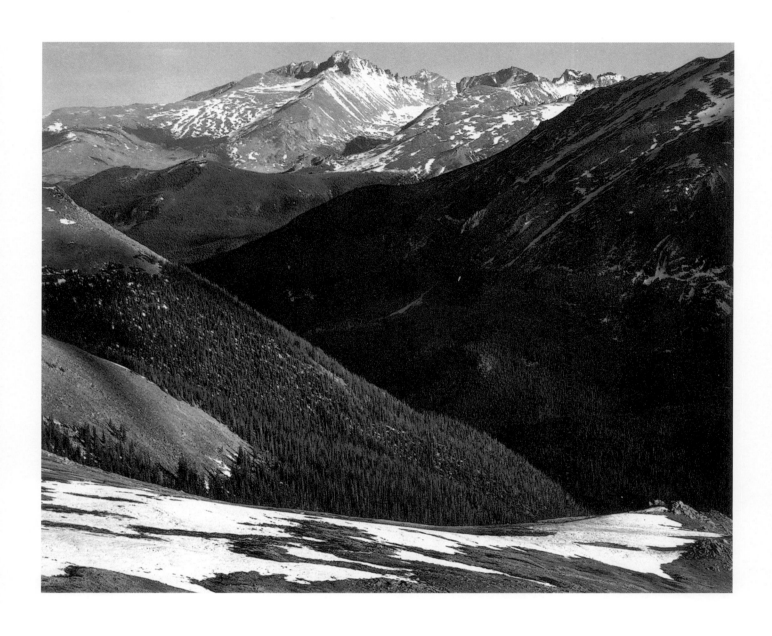

LONG'S PEAK
Rocky Mountain National Park, Colorado

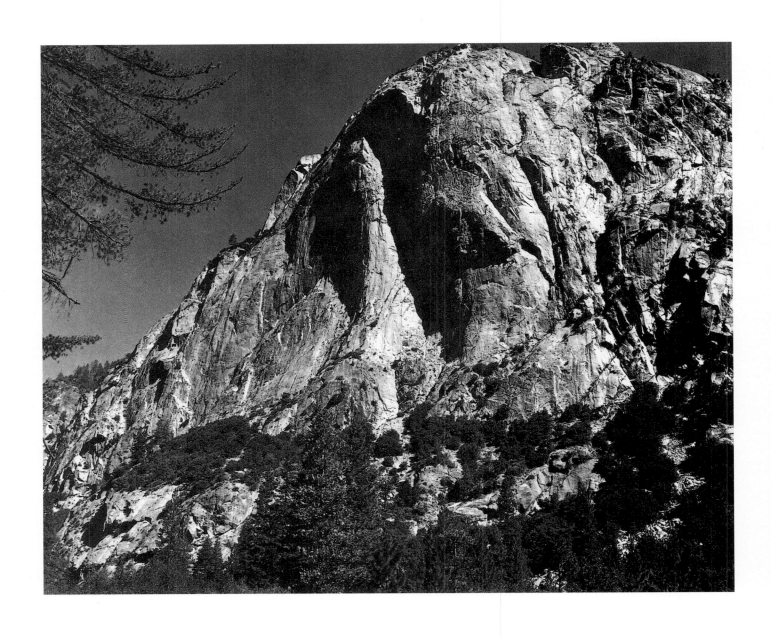

NORTH DOME
Kings River Canyon, California

EVENING, McDONALD LAKE
Glacier National Park, Montana

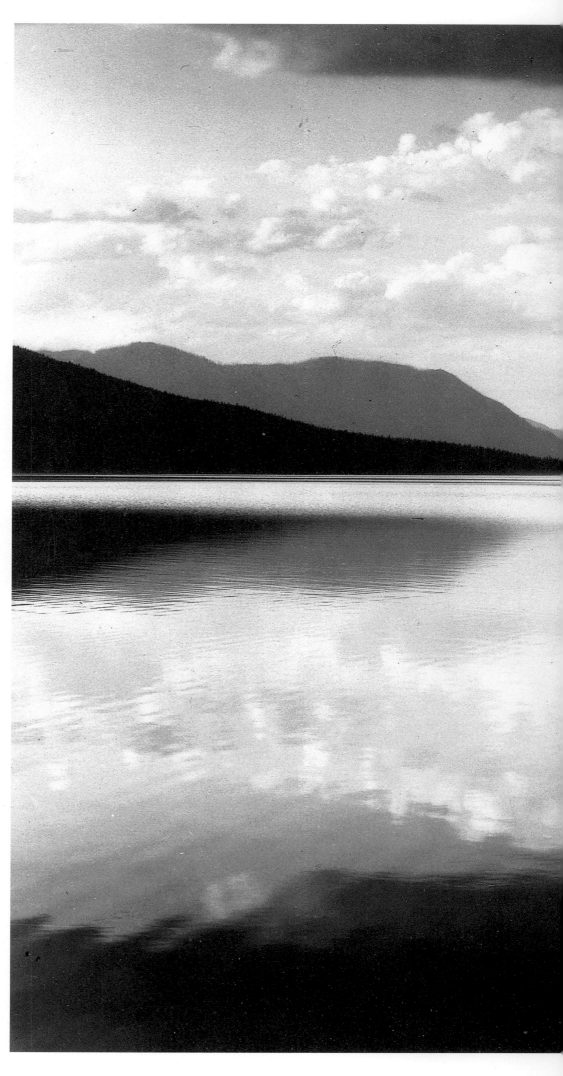

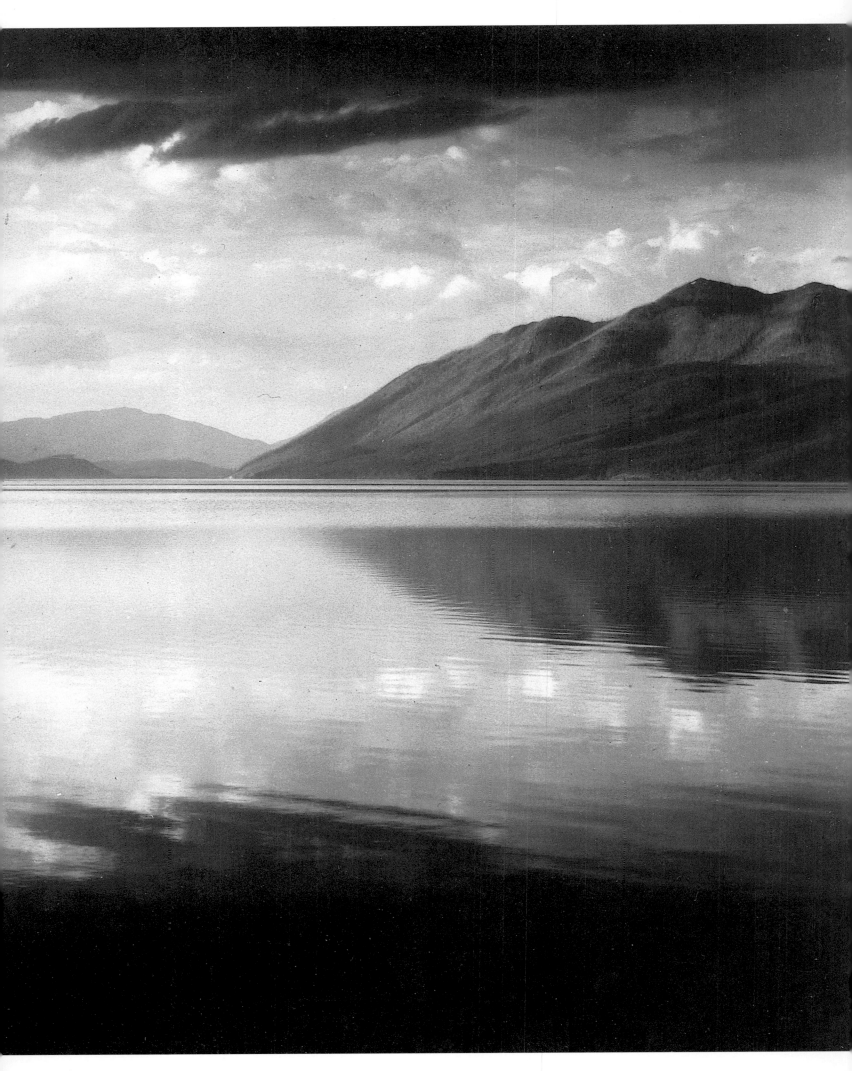

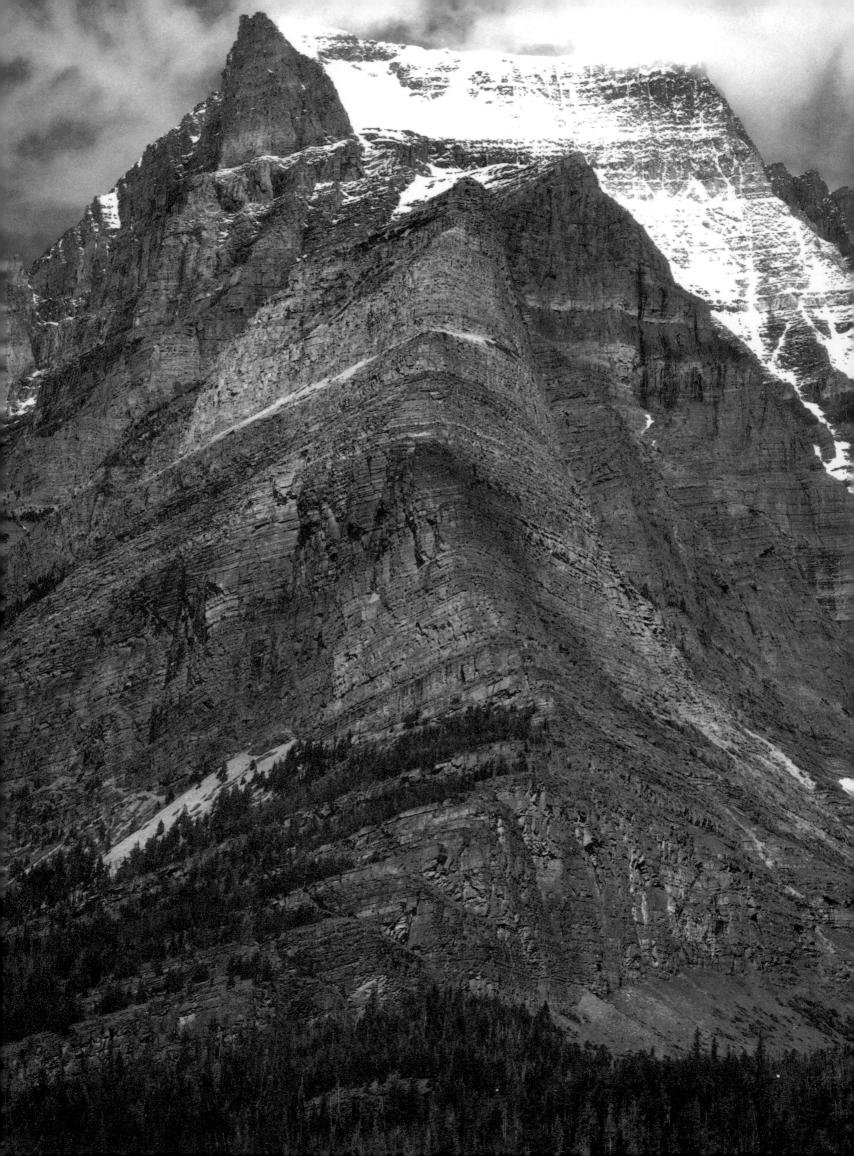

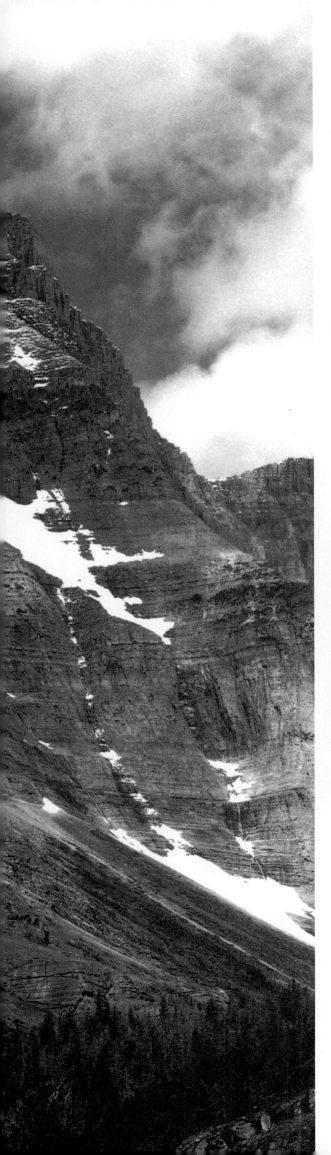

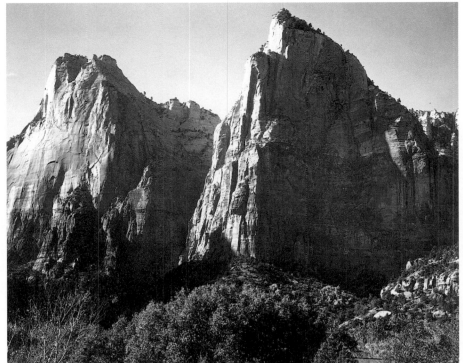

Left:
GOING-TO-THE-SUN MOUNTAIN
Glacier National Park, Montana

Top:
COURT OF THE PATRIARCHS
Zion National Park, Utah

Above:
ROCKS AT SILVER GATE
Yellowstone National Park, Wyoming

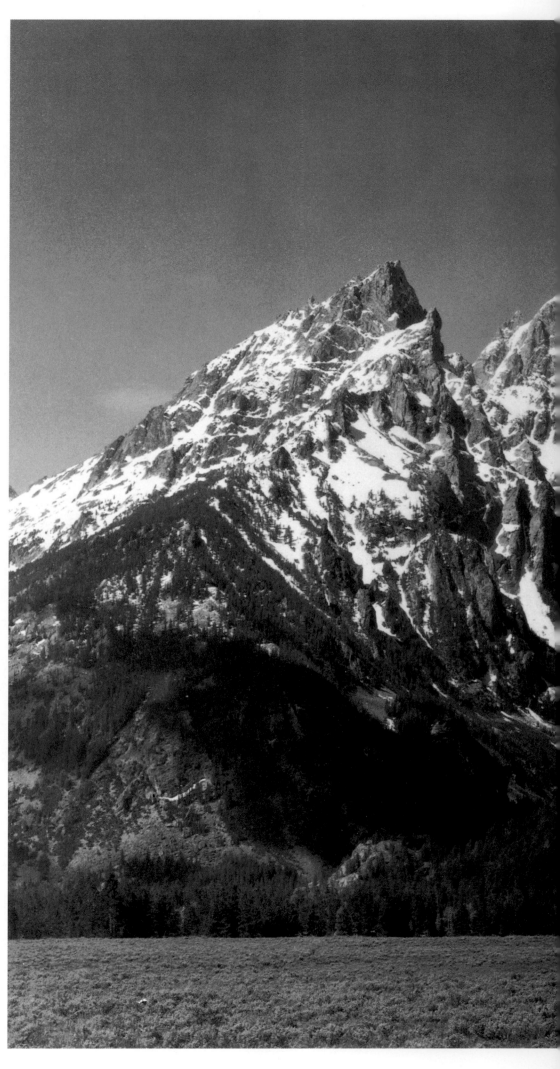

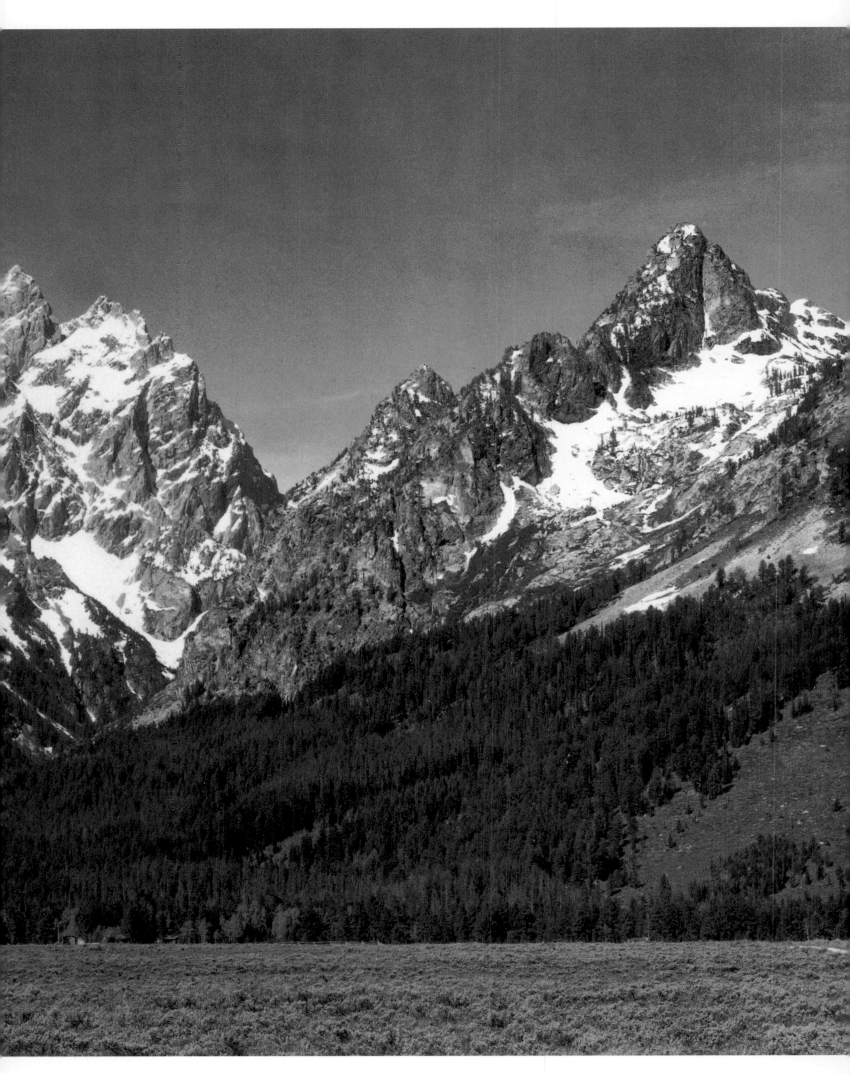

OWENS VALLEY FROM SAWMILL PASS
Kings River Canyon, California

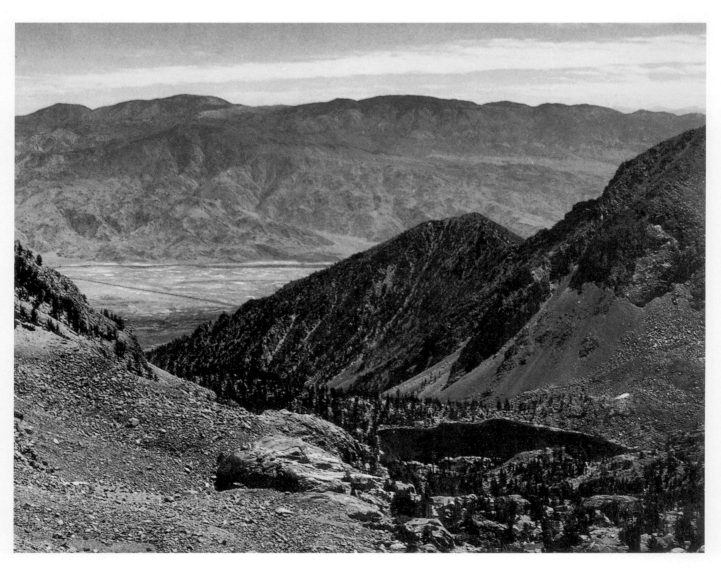

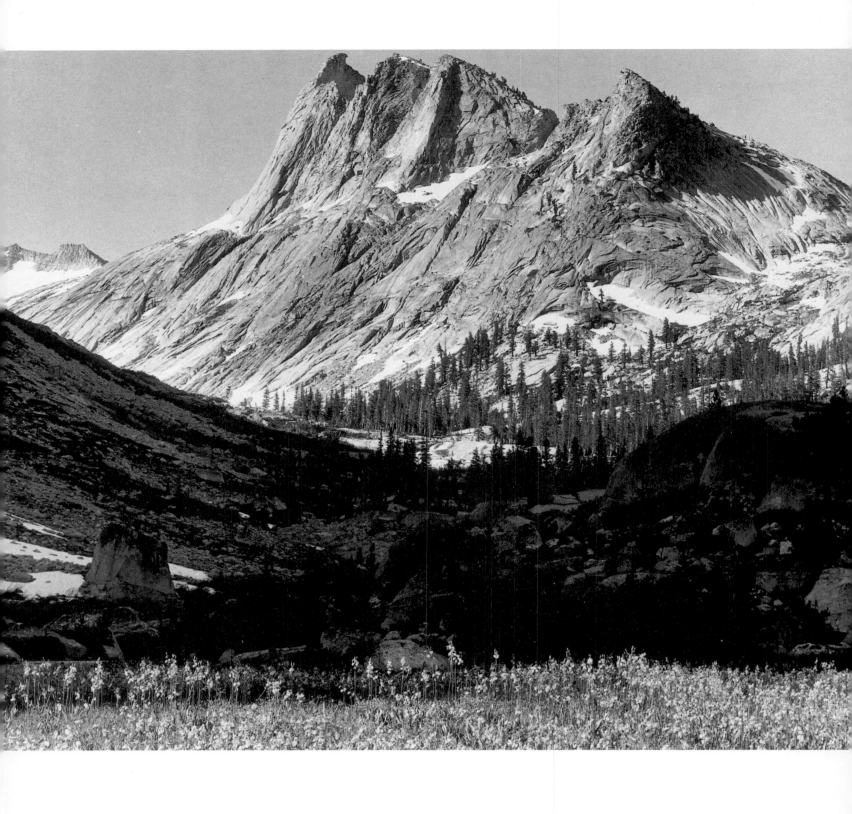

BOARING RIVER, KINGS REGION
Kings River Canyon, California

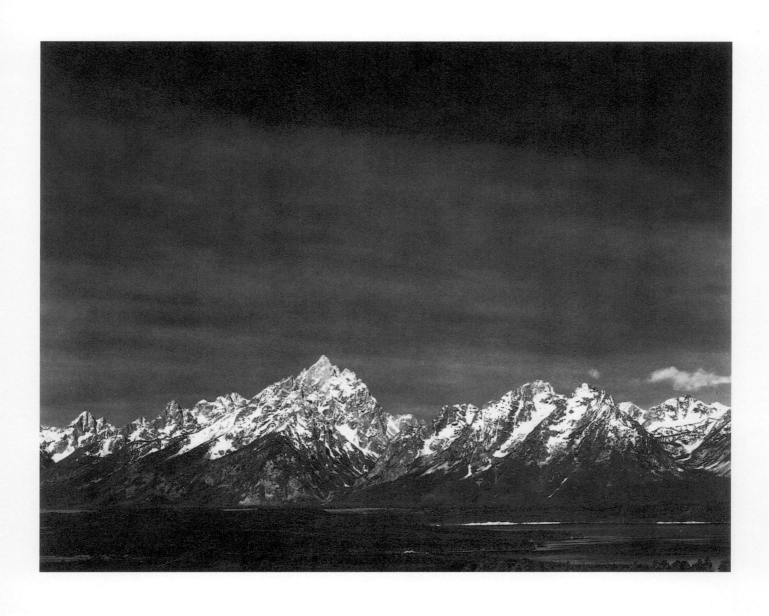

Tetons from Signal Mountain
Grand Teton National Park, Wyoming

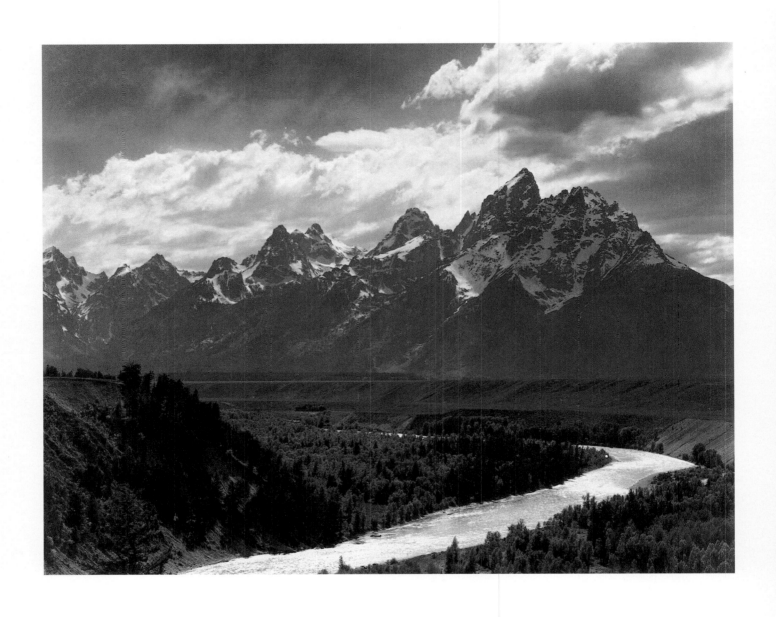

GRAND TETON
Grand Teton National Park, Wyoming

Below:
LONG'S PEAK FROM ROAD
Rocky Mountain National Park, Colorado

Right:
KEARSAGE PINNACLES
Kings River Canyon, California

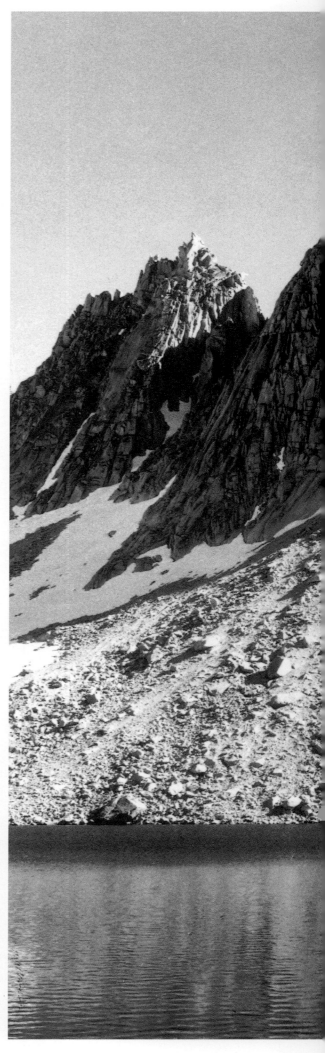

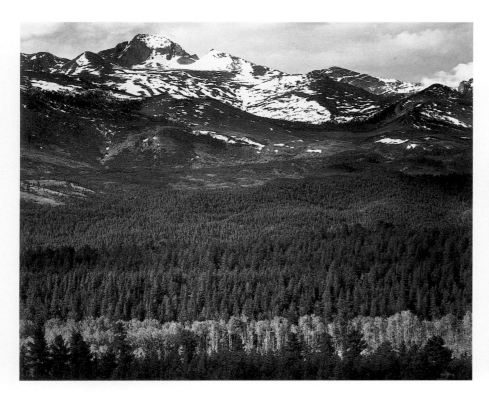

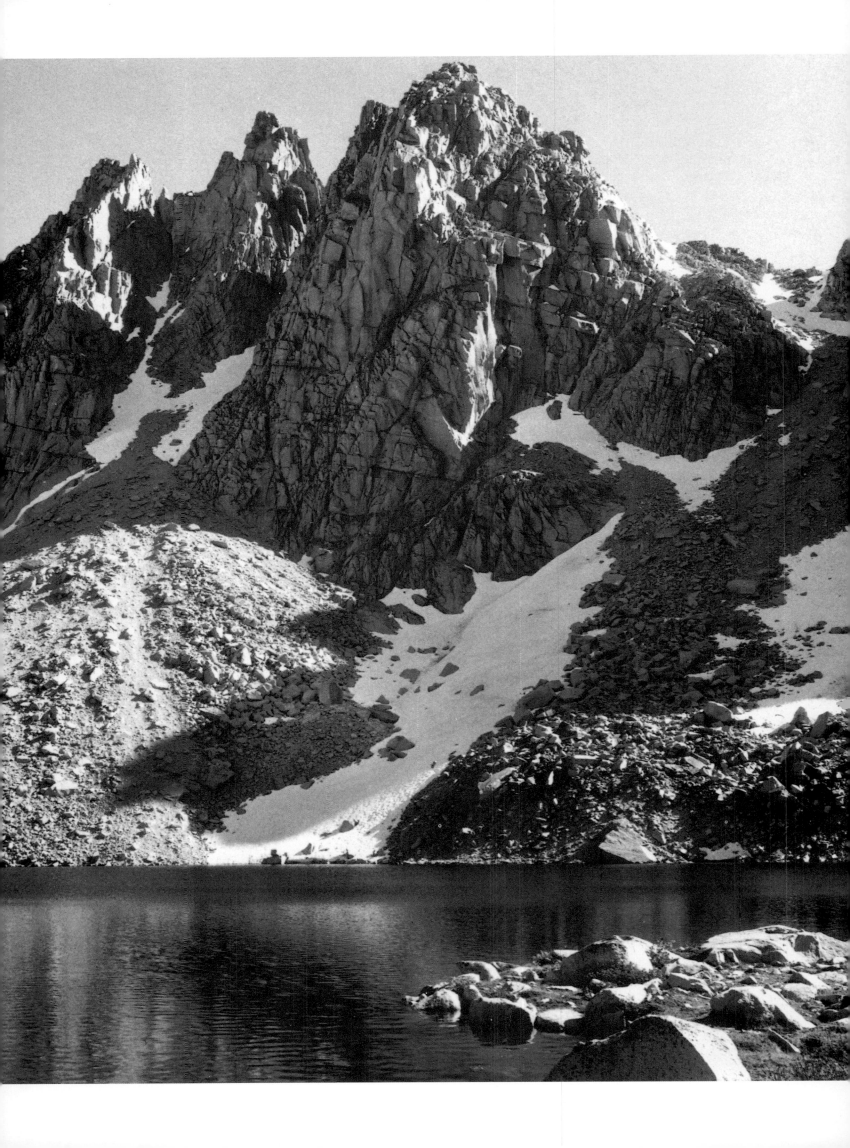

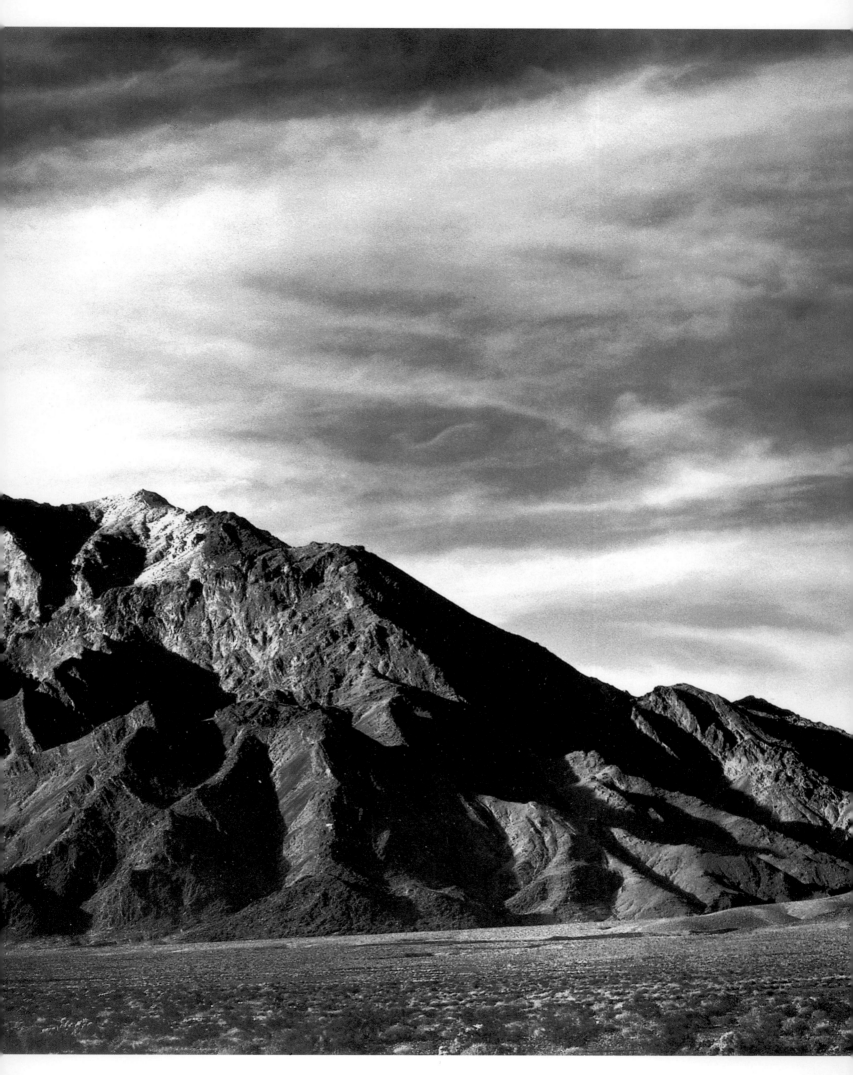

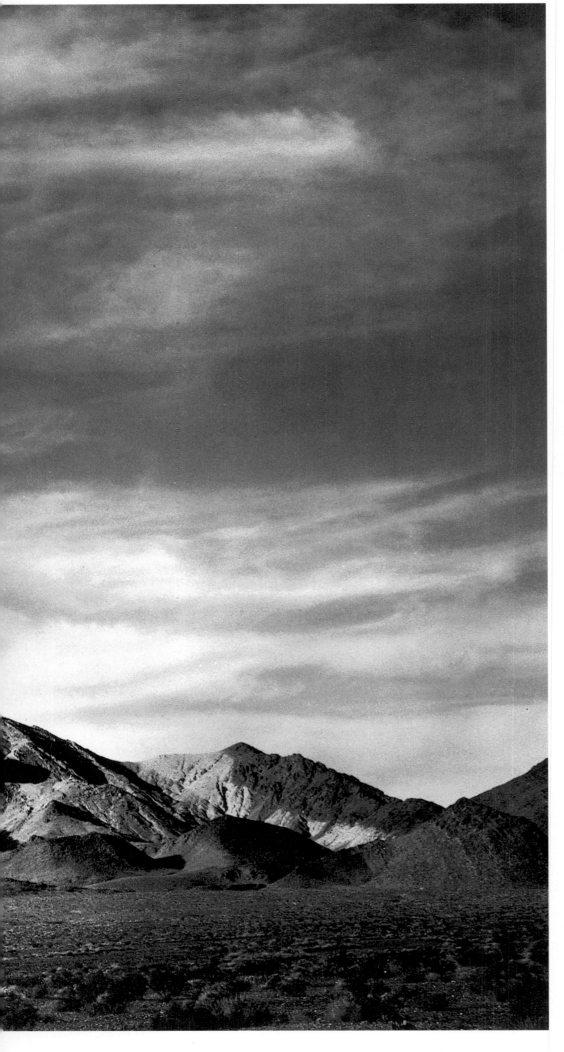

NEAR DEATH VALLEY
Death Valley National Monument, California

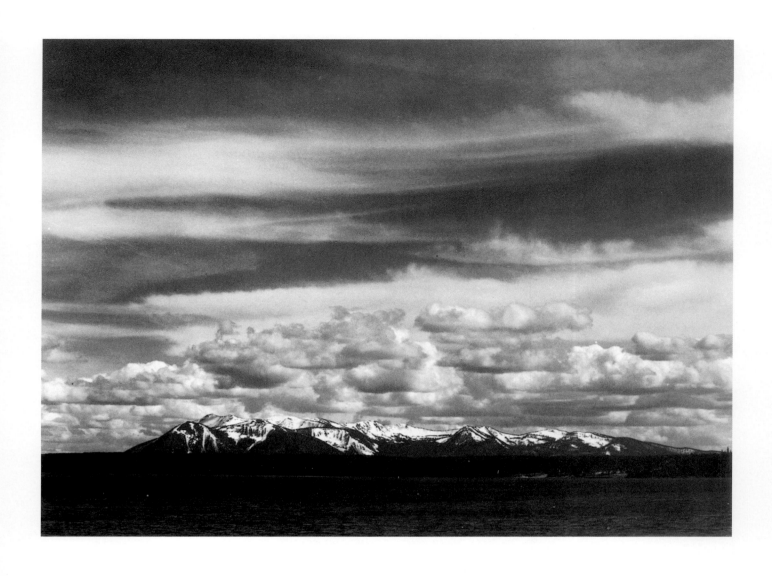

YELLOWSTONE LAKE, MT. SHERIDAN
Yellowstone National Park, Wyoming

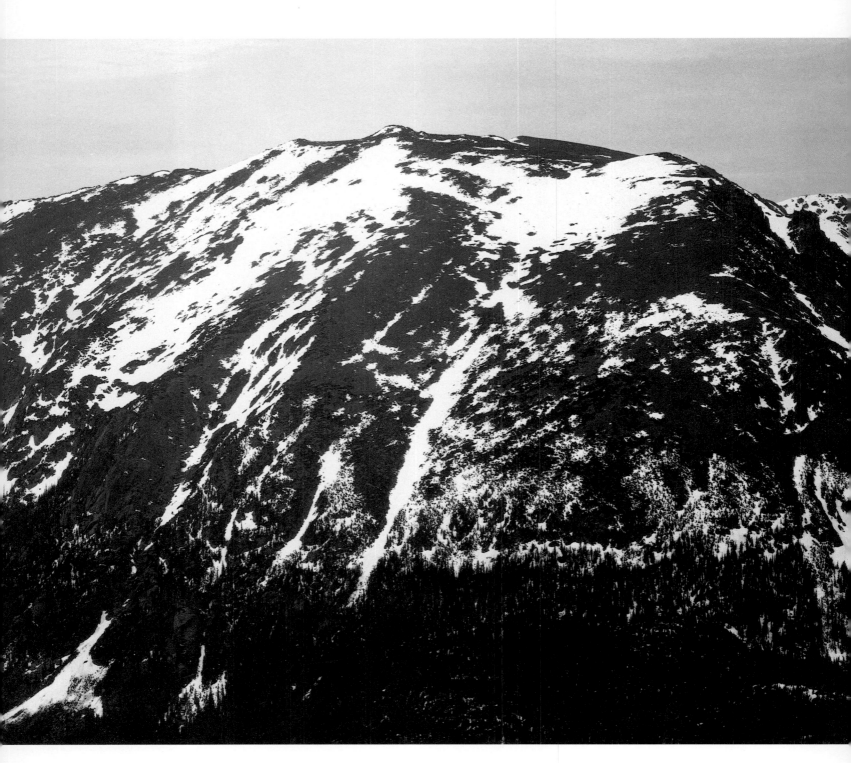

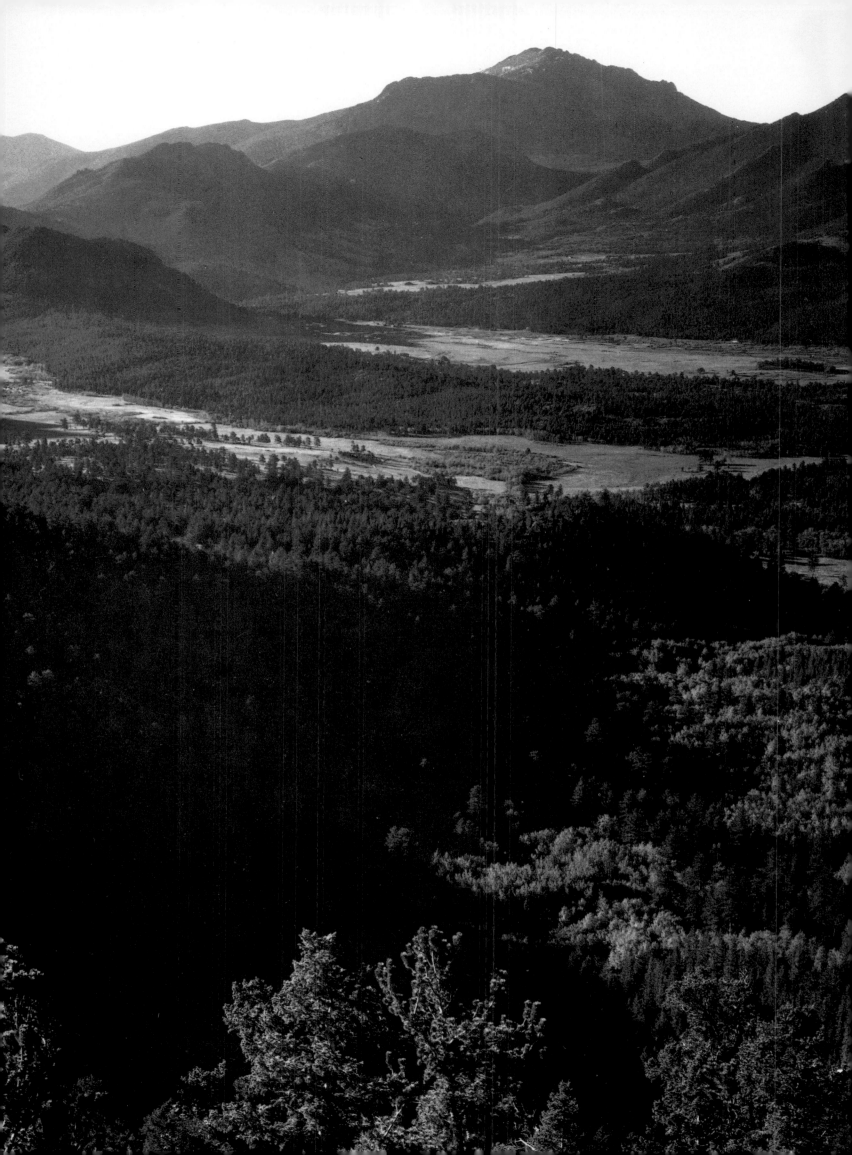

62

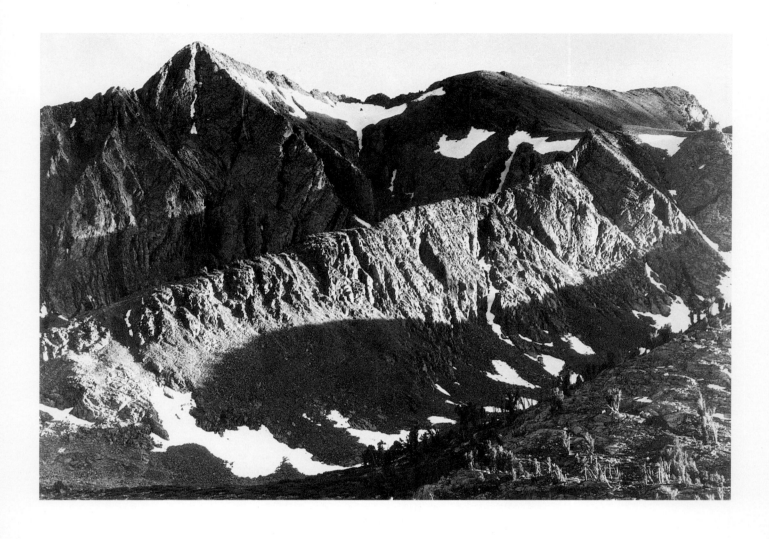

PEAK ABOVE WOODY LAKE
Kings River Canyon, California

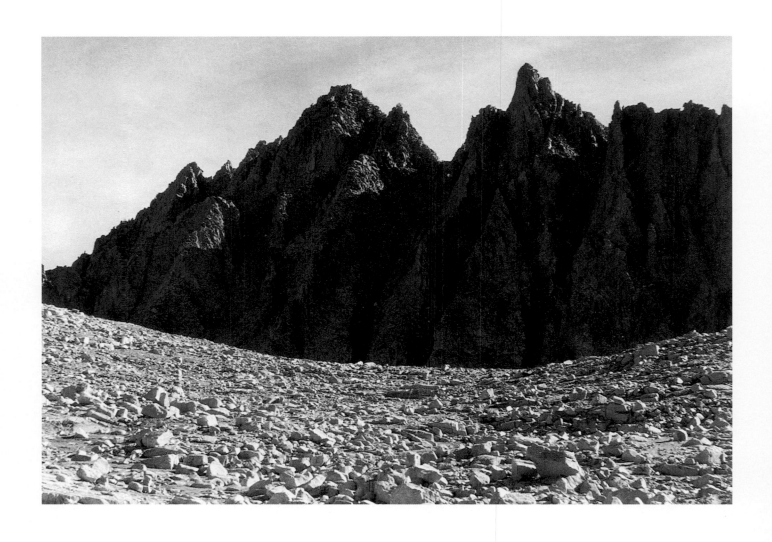

BISHOP PASS
Kings River Canyon, California

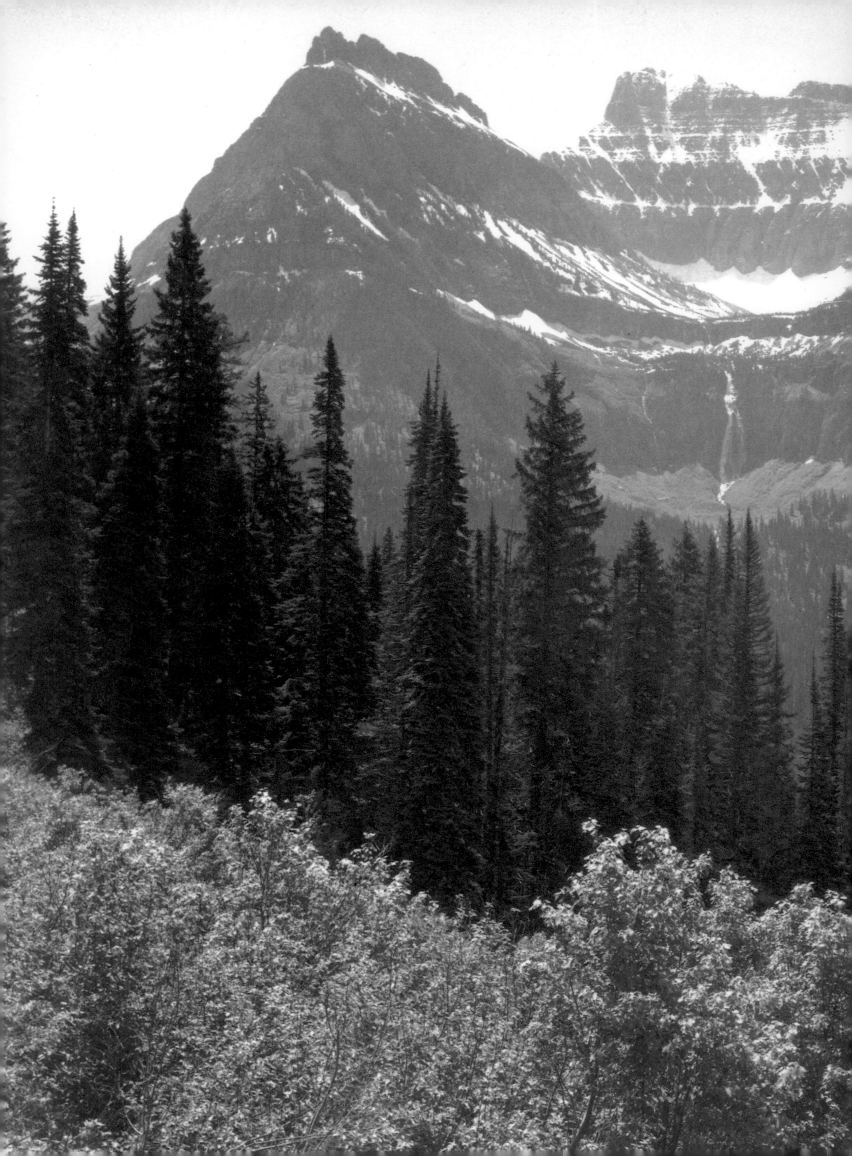

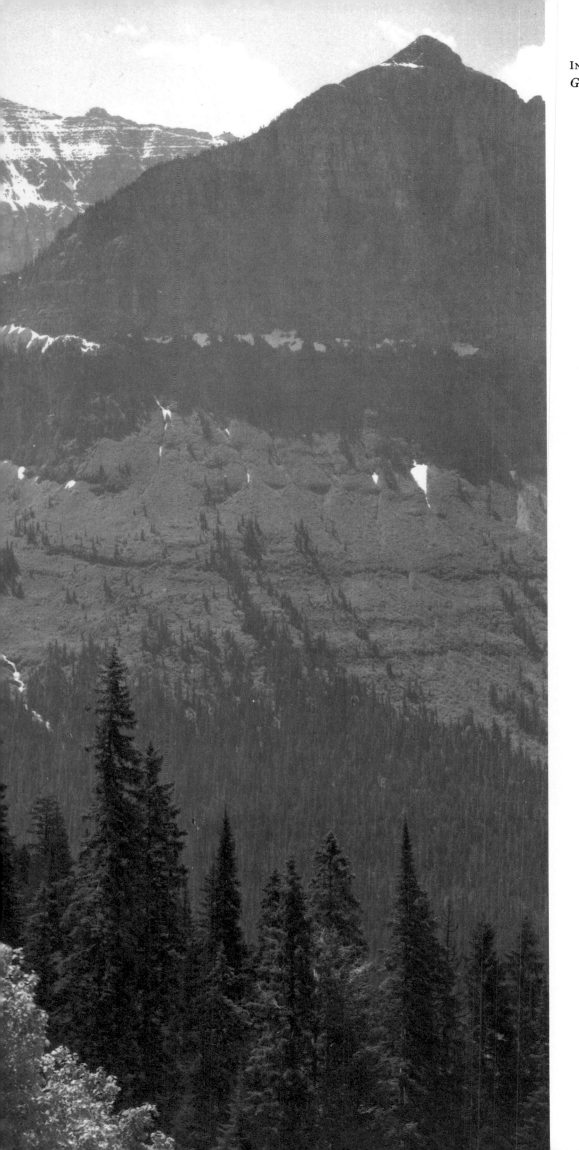

In Glacier National Park
Glacier National Park, Montana

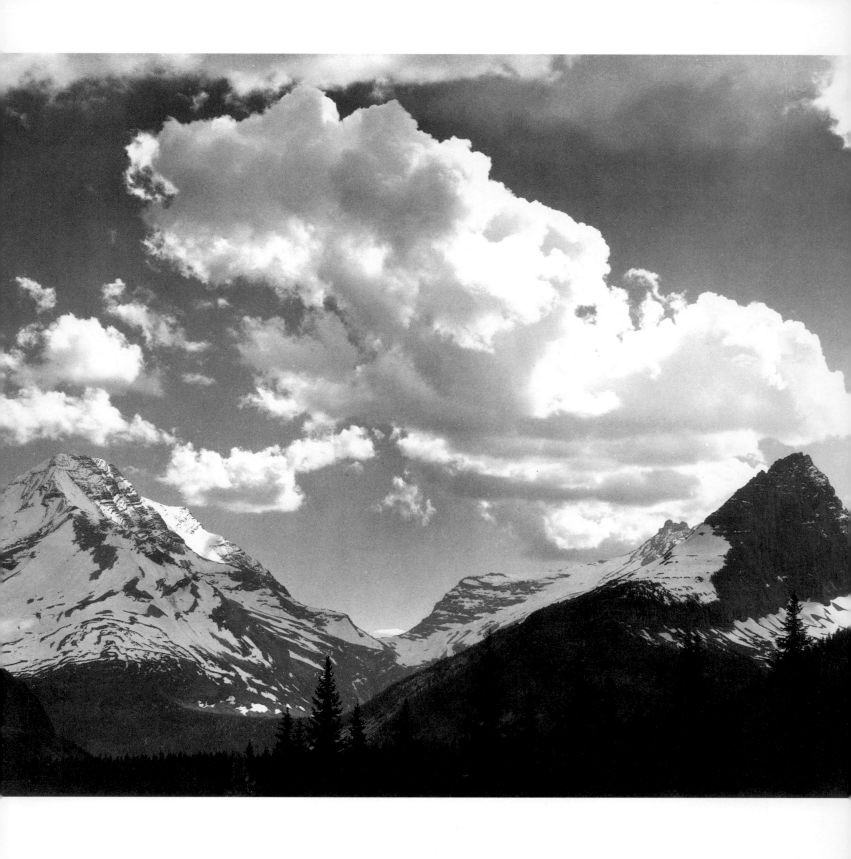

IN GLACIER NATIONAL PARK
Glacier National Park, Montana

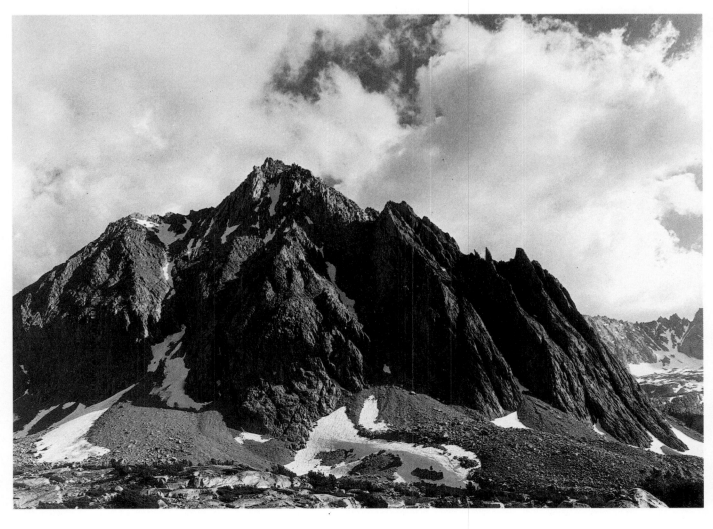

CENTER PEAK, CENTER BASIN
Kings River Canyon, California

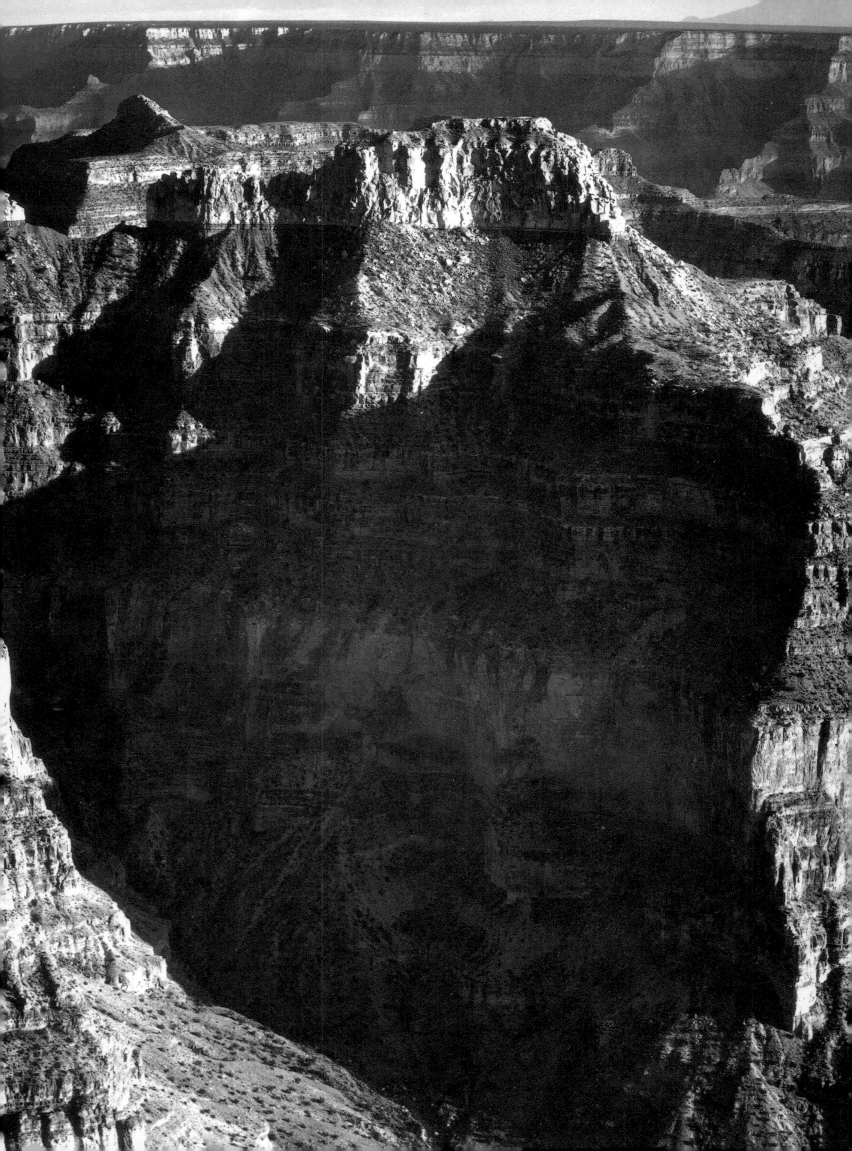

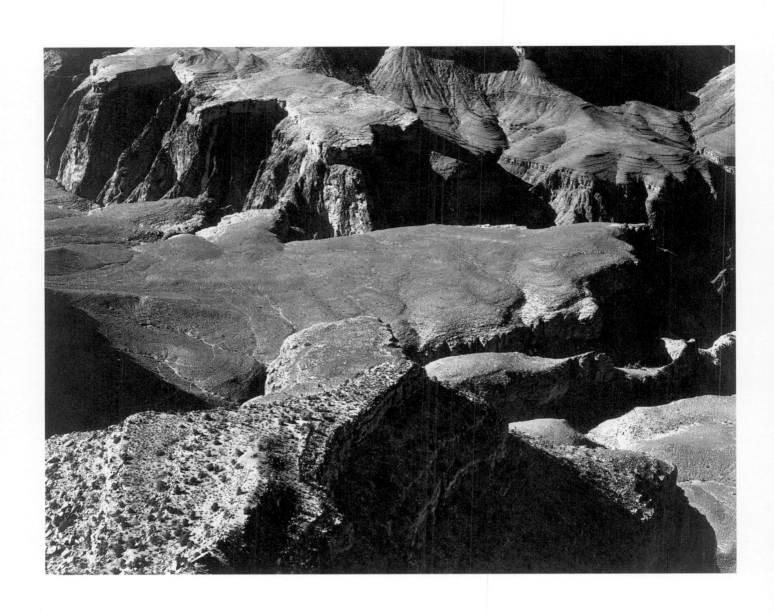

Opposite:
GRAND CANYON FROM NORTH RIM, 1941
Grand Canyon National Park, Arizona

Above:
GRAND CANYON NATIONAL PARK
Grand Canyon National Park, Arizona

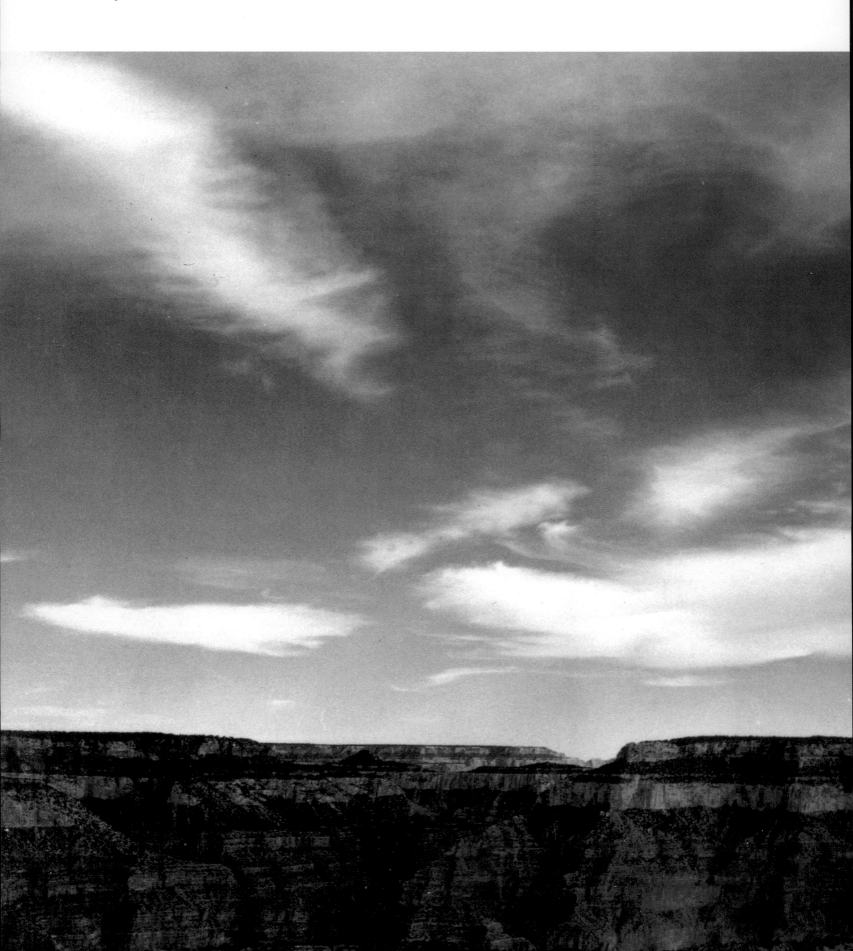

GRAND CANYON NATIONAL PARK
Grand Canyon National Park, Arizona

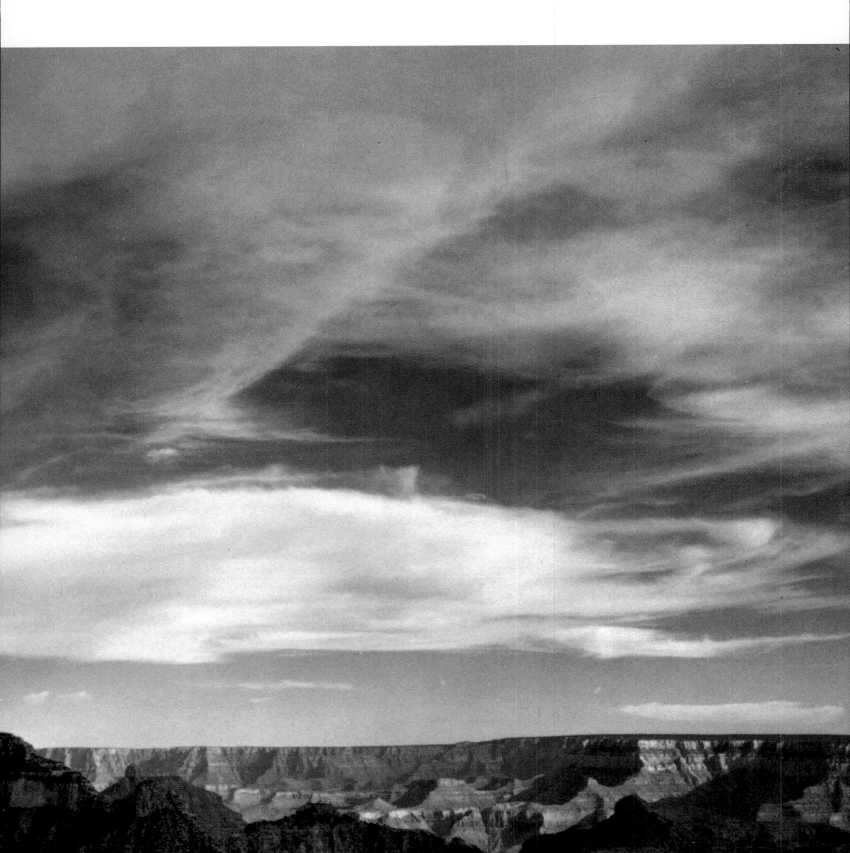

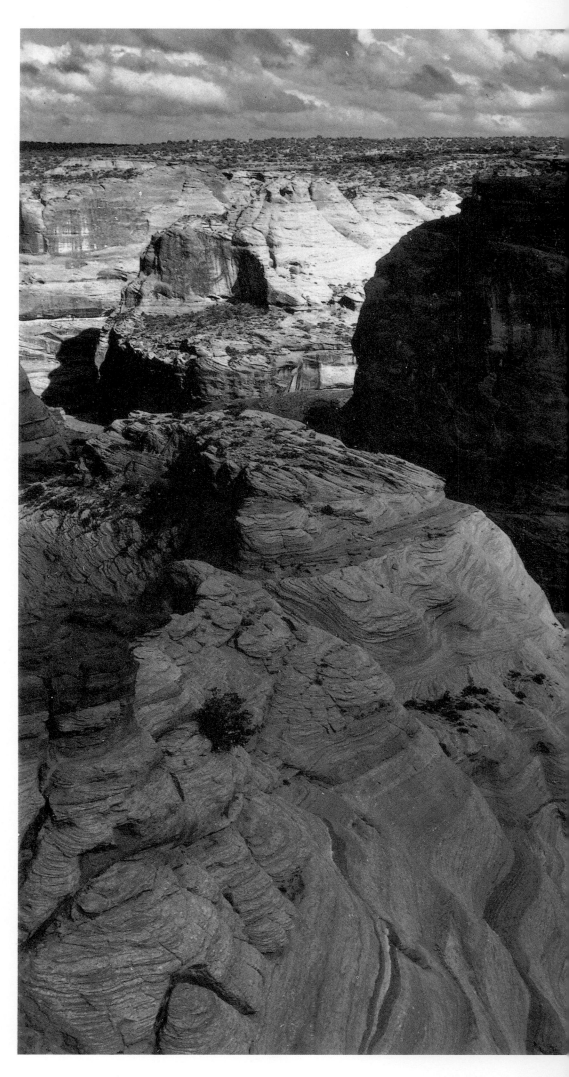

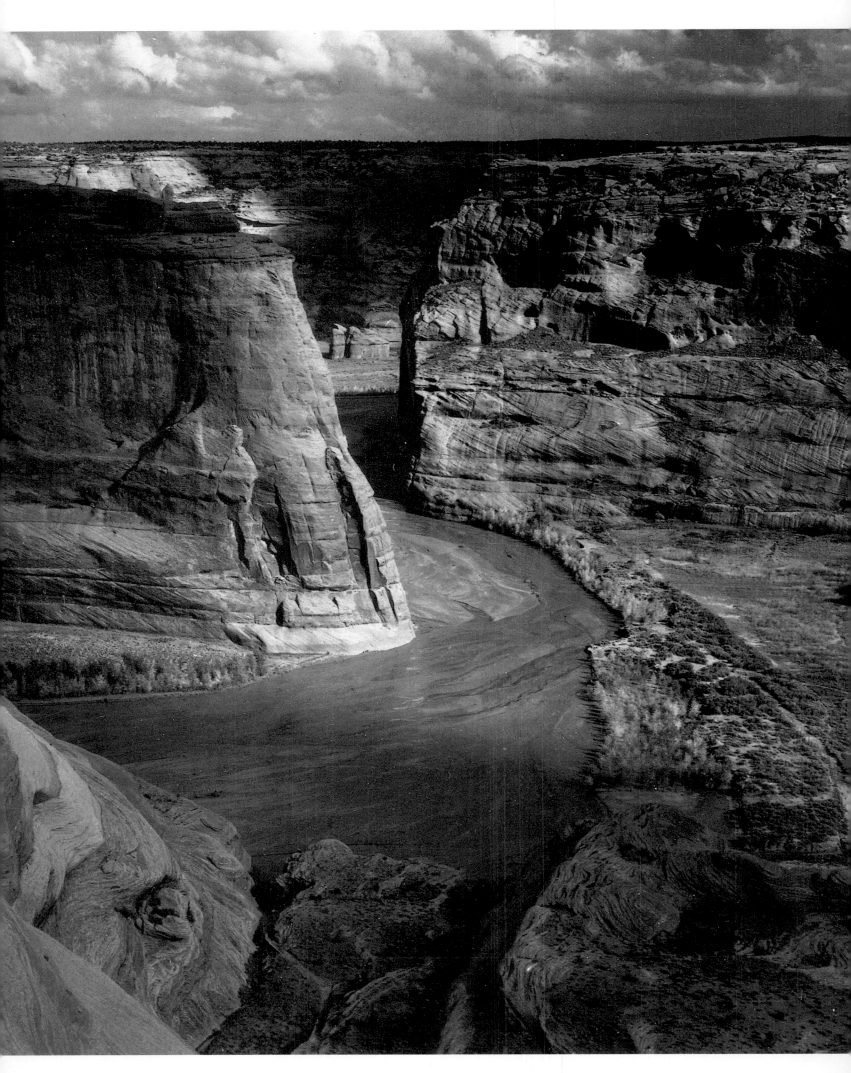

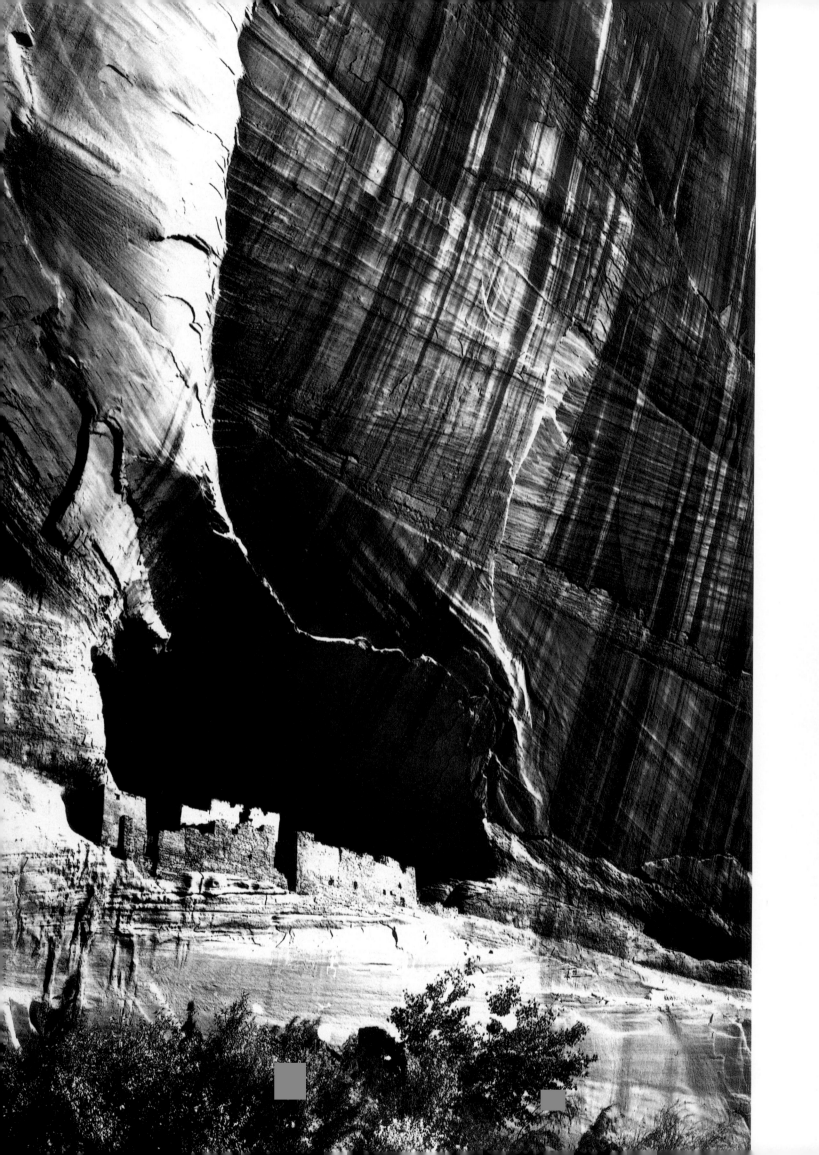

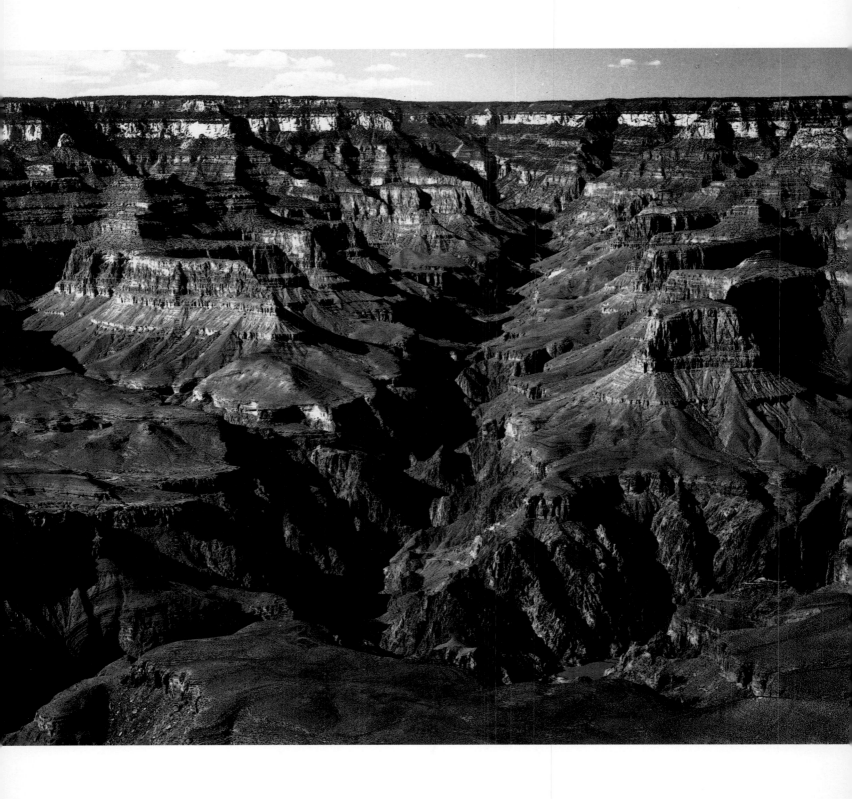

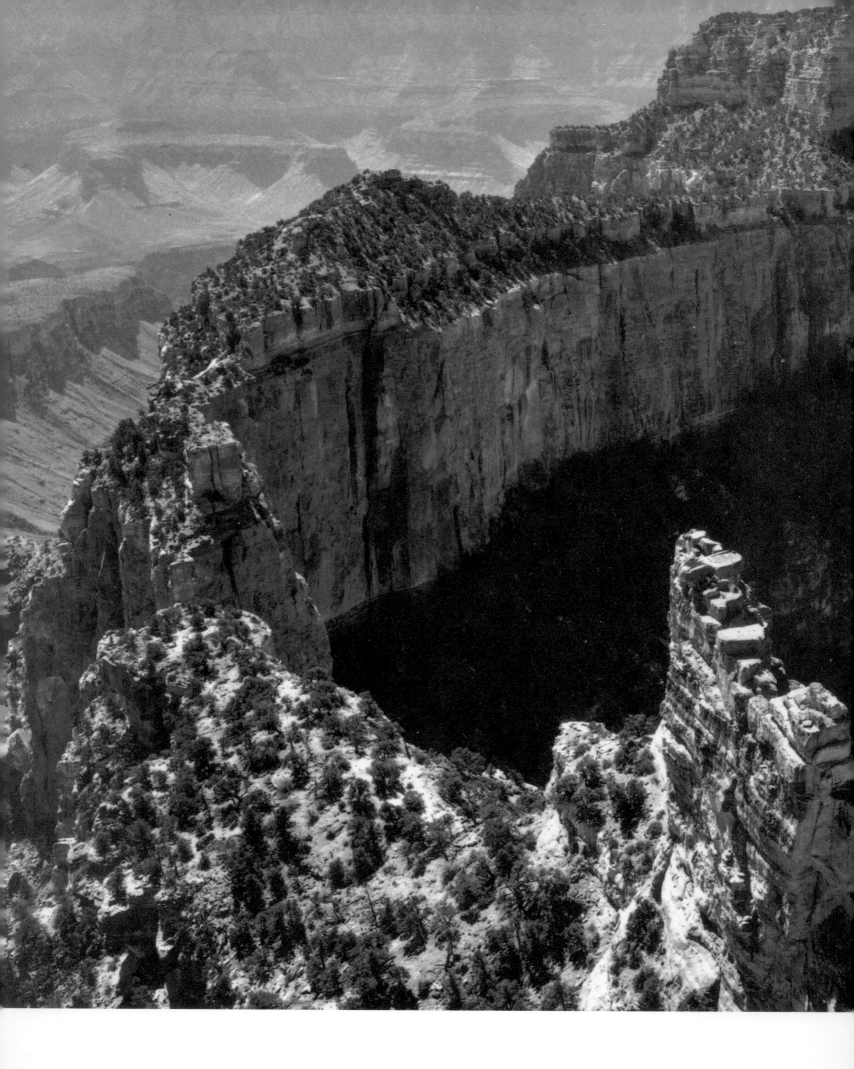

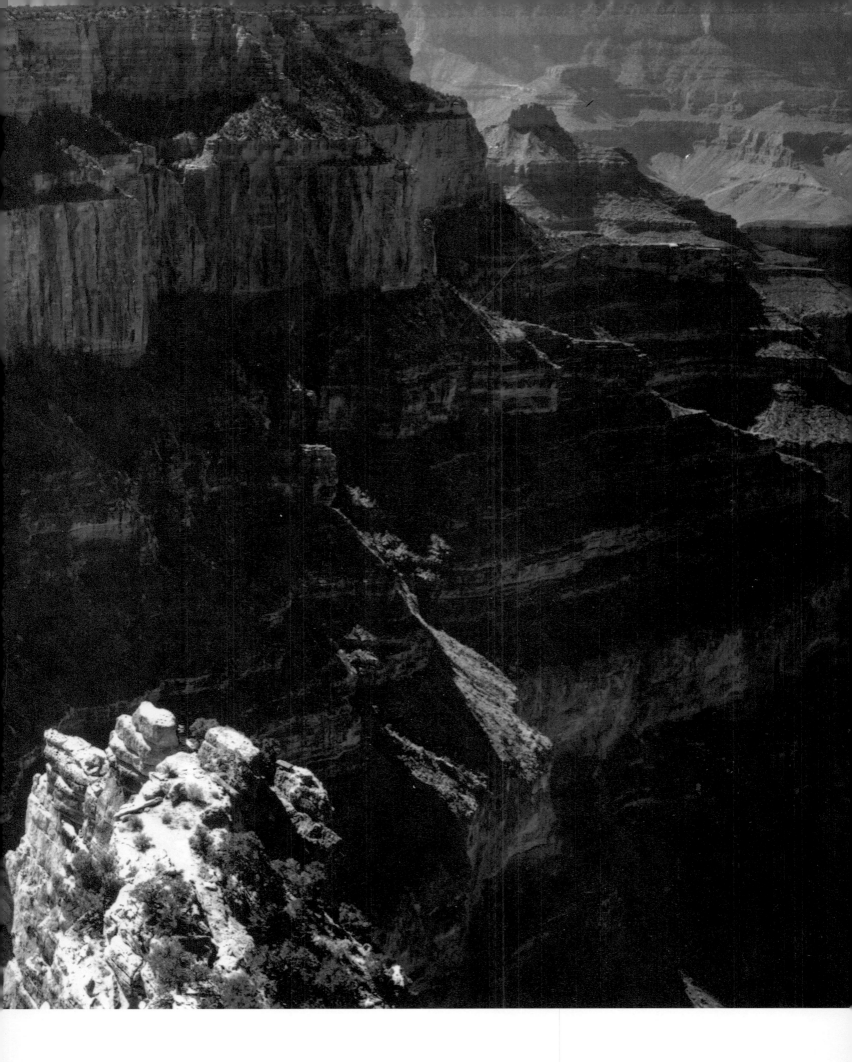

GRAND CANYON NATIONAL PARK
Grand Canyon National Park, Arizona

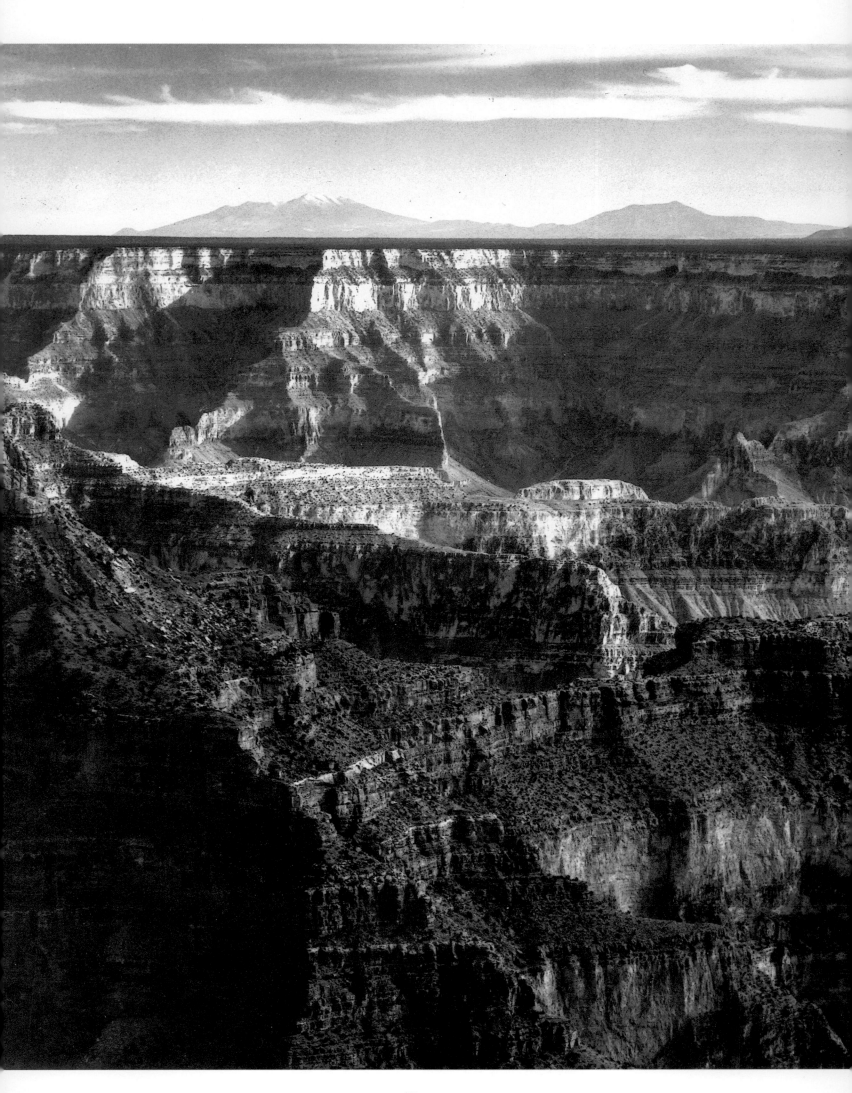

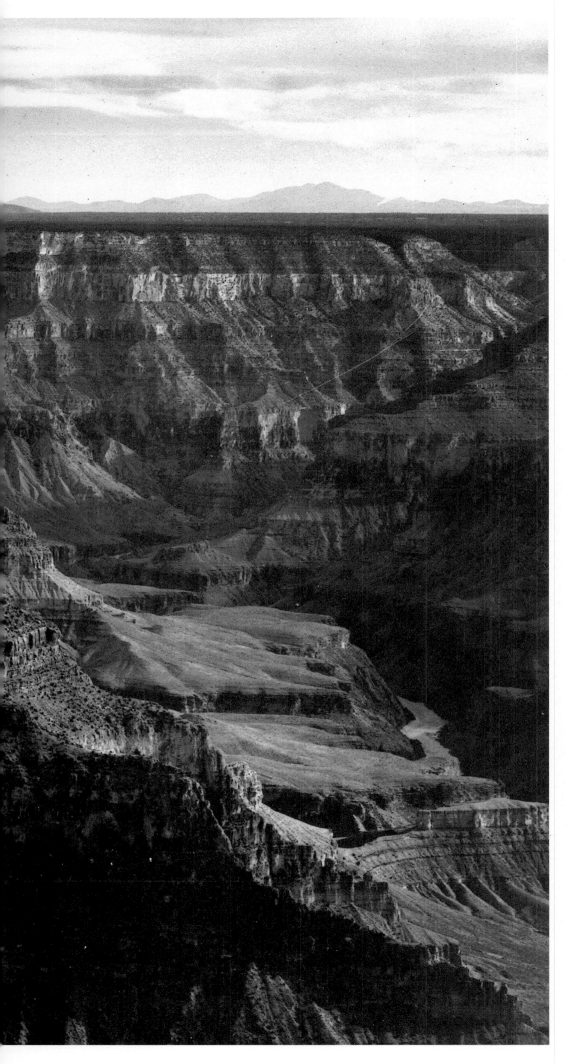

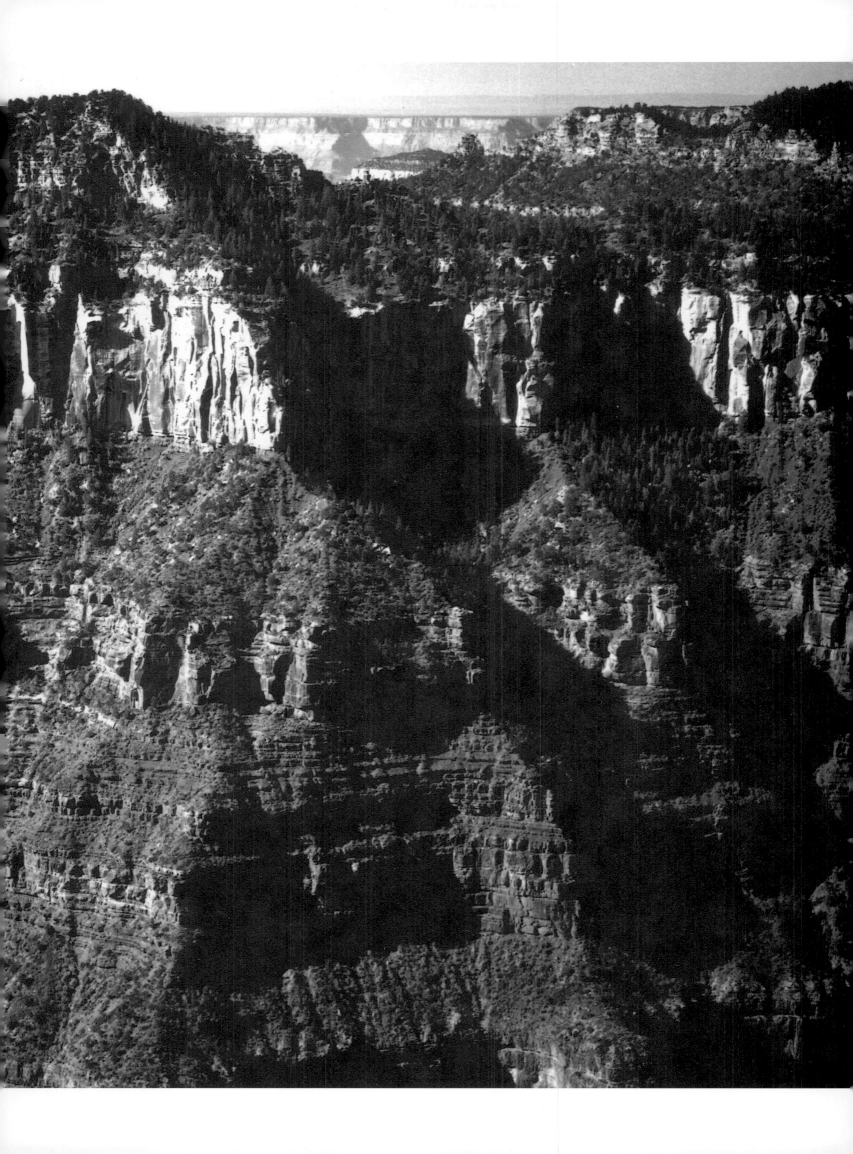

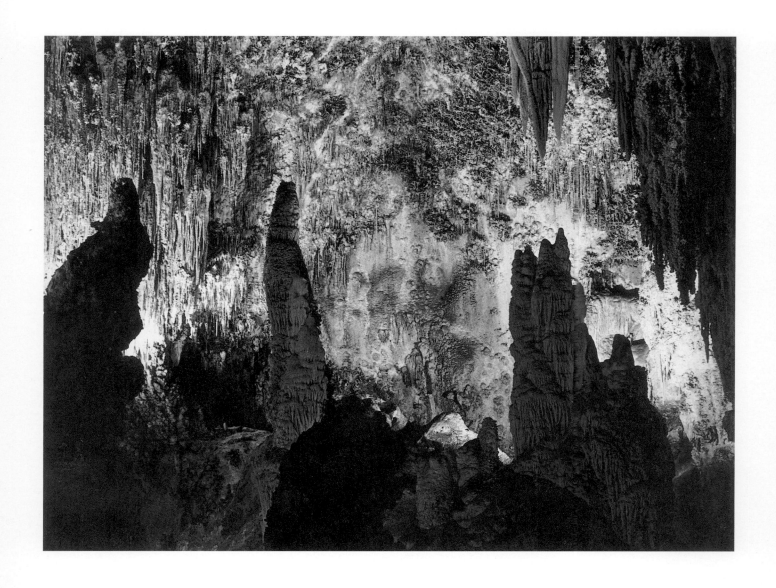

Above:
IN THE QUEEN'S CHAMBER
Carlsbad Caverns National Park, New Mexico

Opposite:
THE GIANT DOMES IN THE INTERIOR
OF CARLSBAD CAVERNS
Carlsbad Caverns National Park, New Mexico

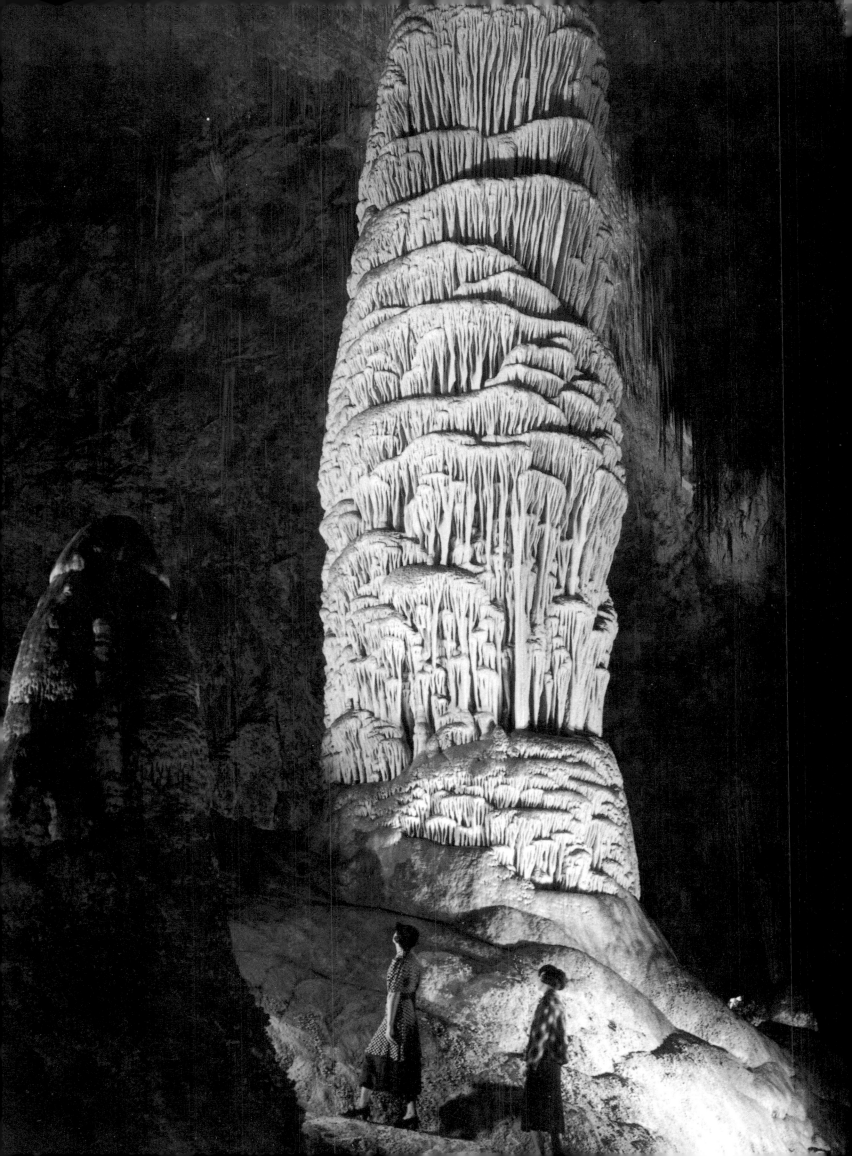

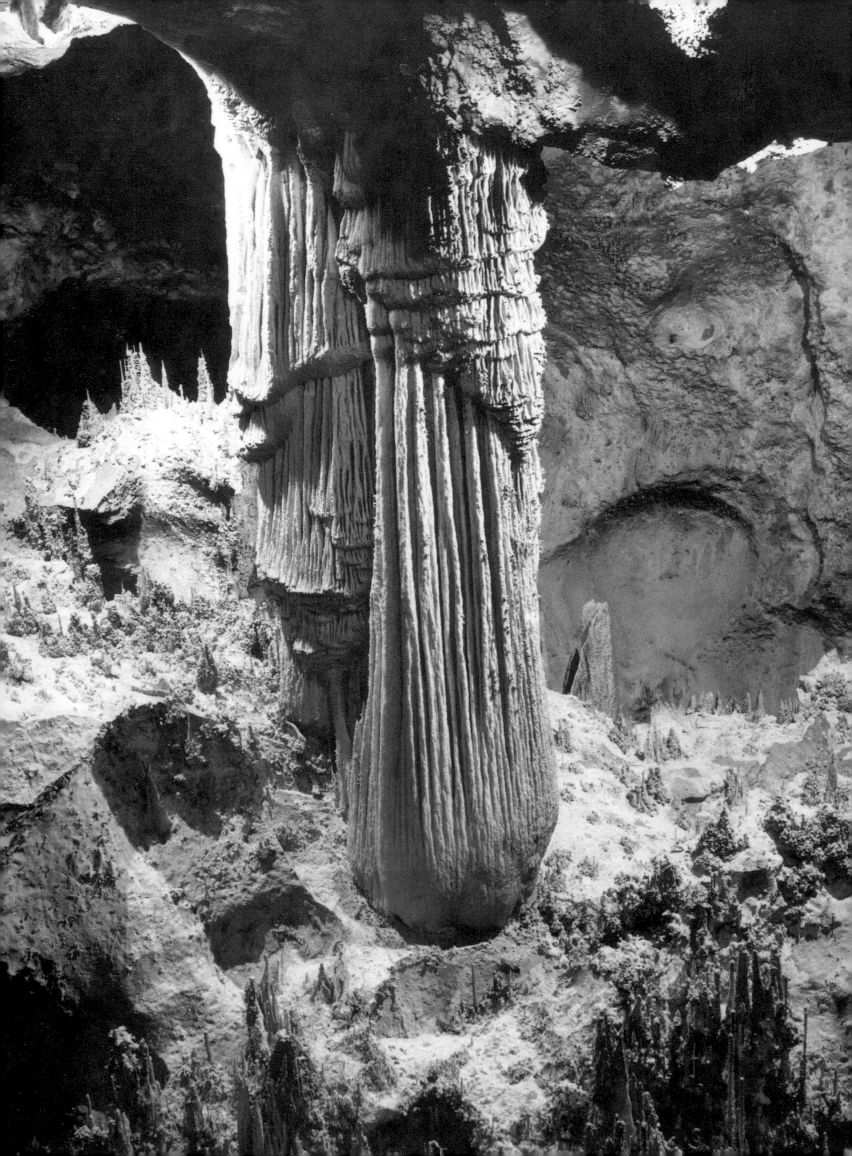

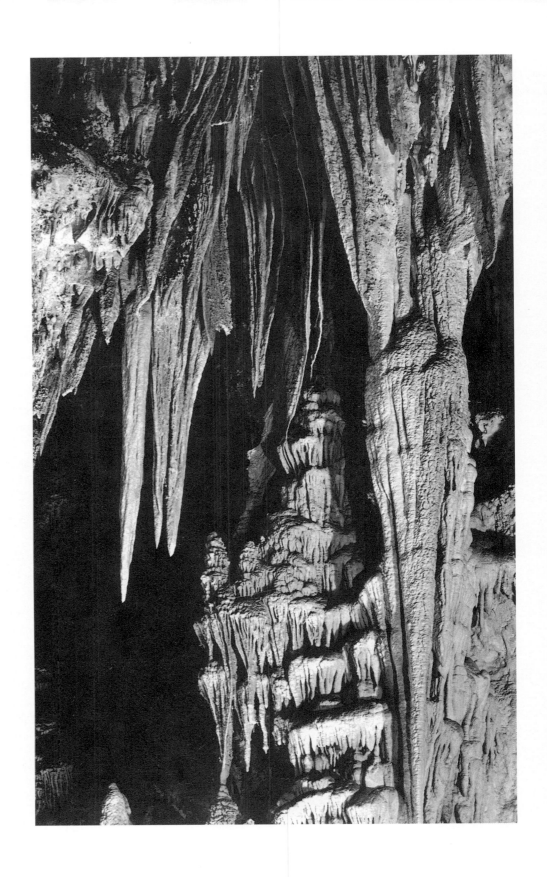

Opposite:
FORMATIONS ABOVE GREEN LAKE
Carlsbad Caverns National Park, New Mexico

Above:
FORMATIONS, ALONG TRAIL IN THE BIG
ROOM, BEYOND THE TEMPLE OF THE SUN
Carlsbad Caverns National Park, New Mexico

THE GIANT DOME, LARGEST
STALAGMITE THUS FAR DISCOVERED
Carlsbad Caverns National Park, New Mexico

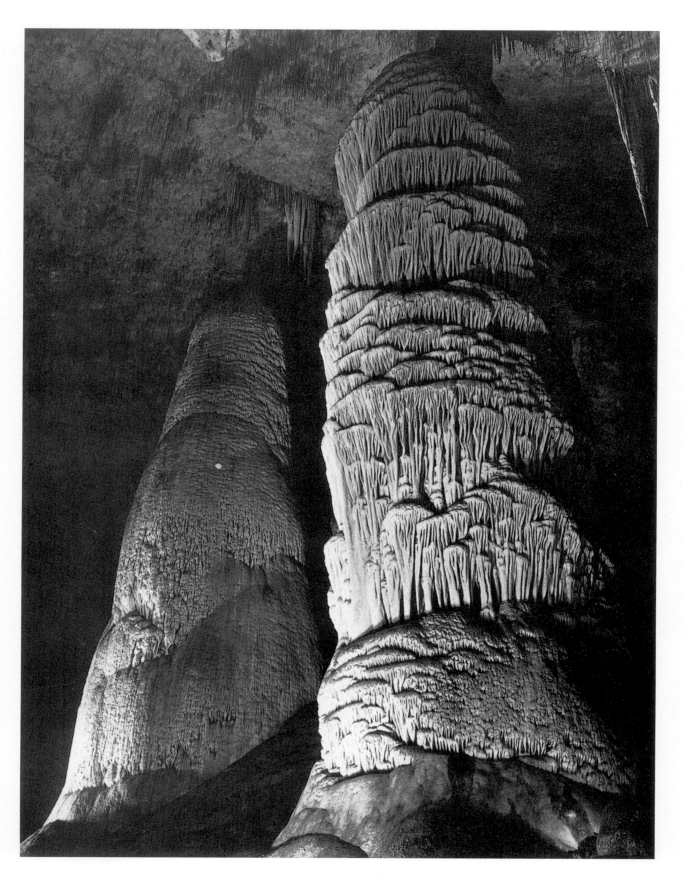

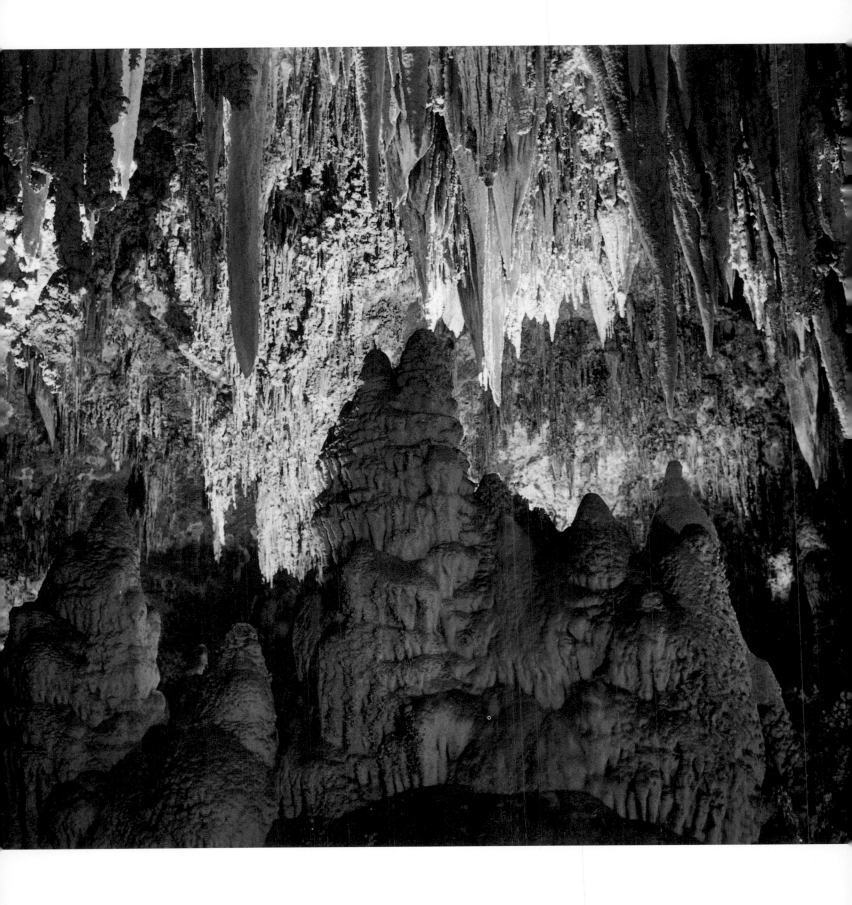

FORMATIONS ALONG THE WALL
OF THE BIG ROOM, NEAR THE CRYSTAL
SPRING HOME
Carlsbad Caverns National Park, New Mexico

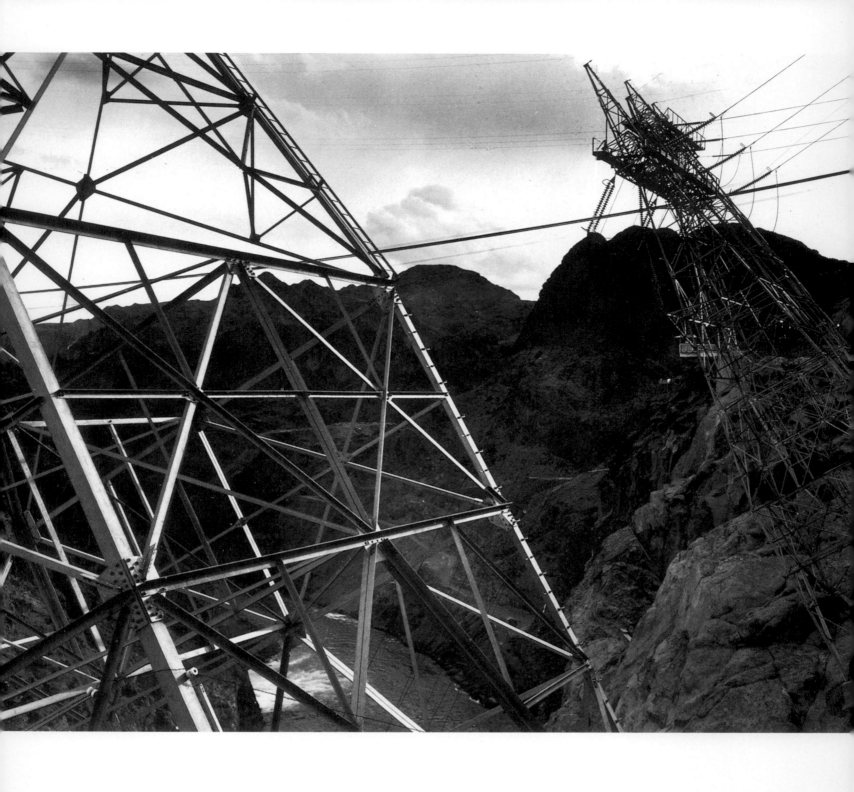

BOULDER DAM, 1941
Boulder Dam, Colorado

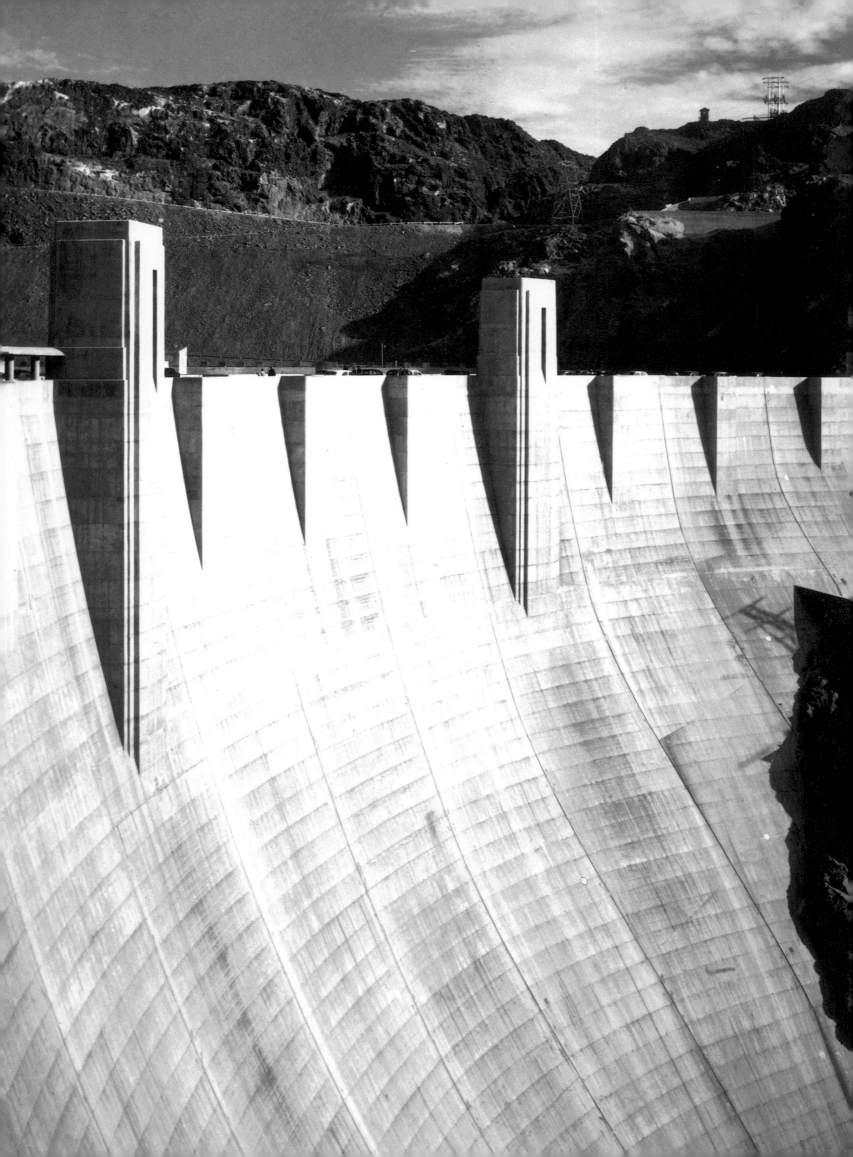

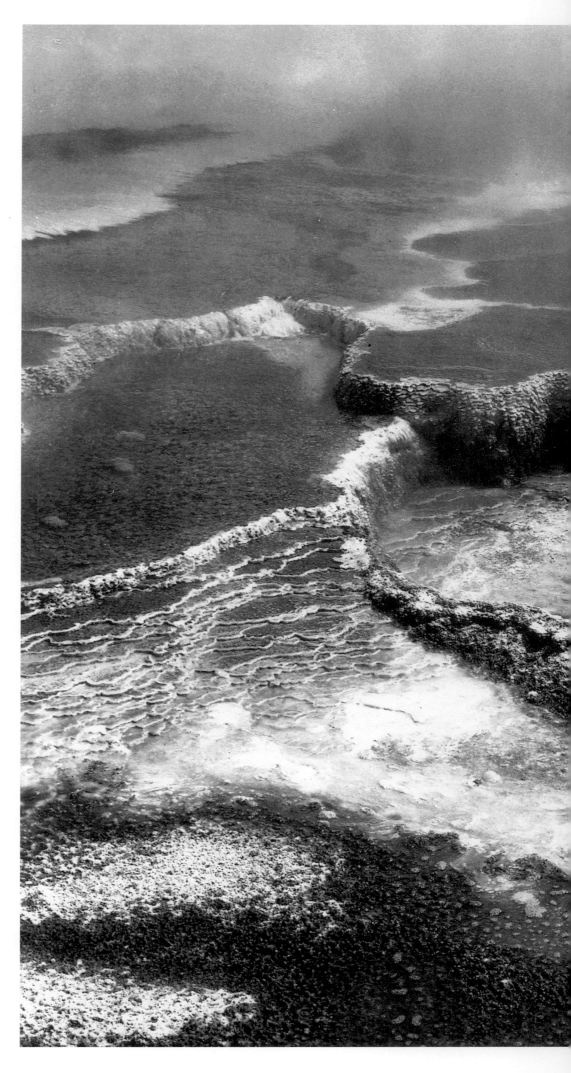

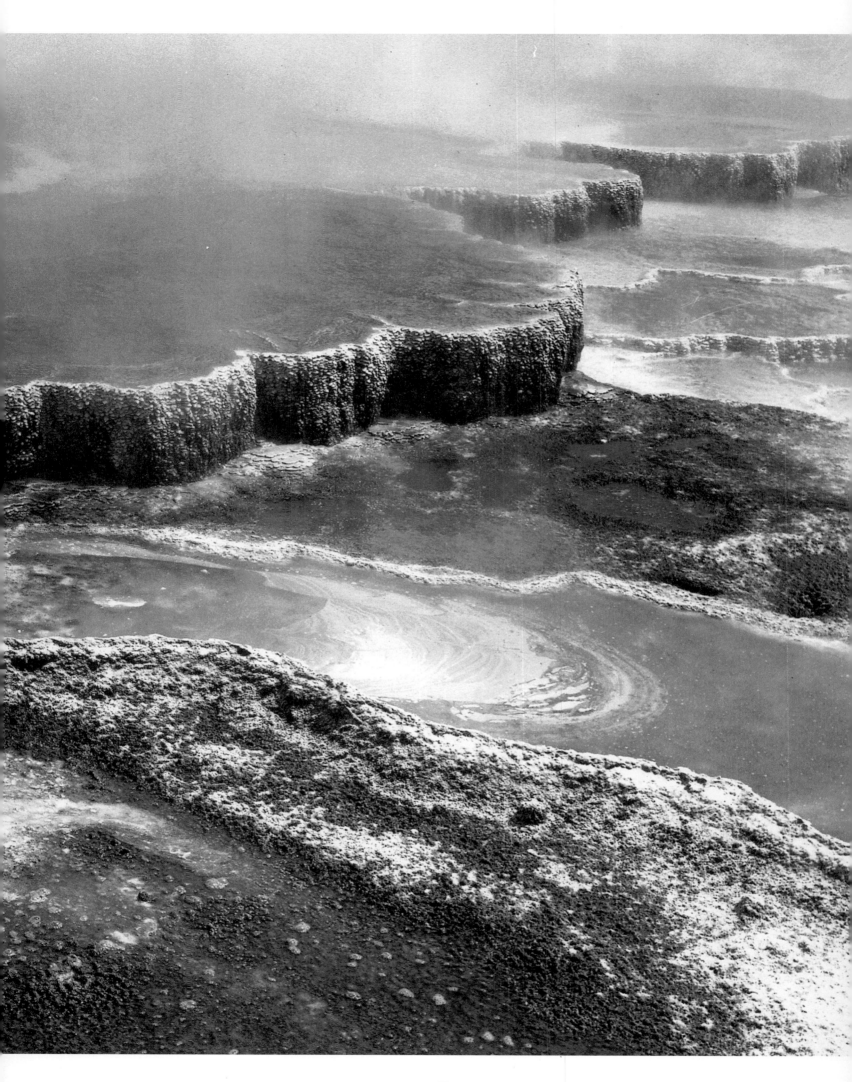

Below:
THE FISHING CONE — YELLOWSTONE LAKE
Yellowstone National Park, Wyoming

Opposite:
OLD FAITHFUL GEYSER
Yellowstone National Park, Wyoming

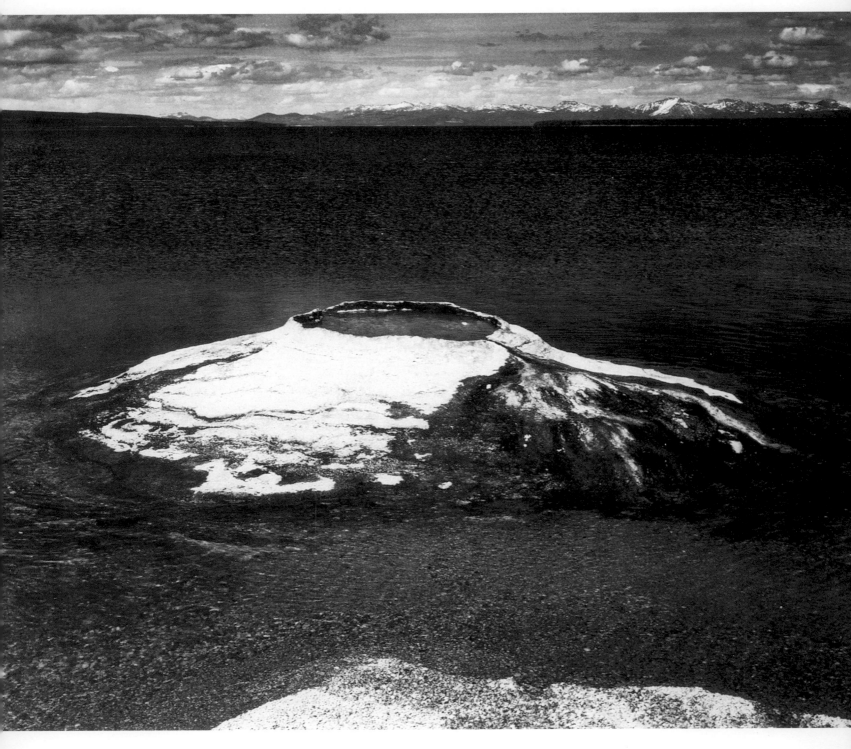

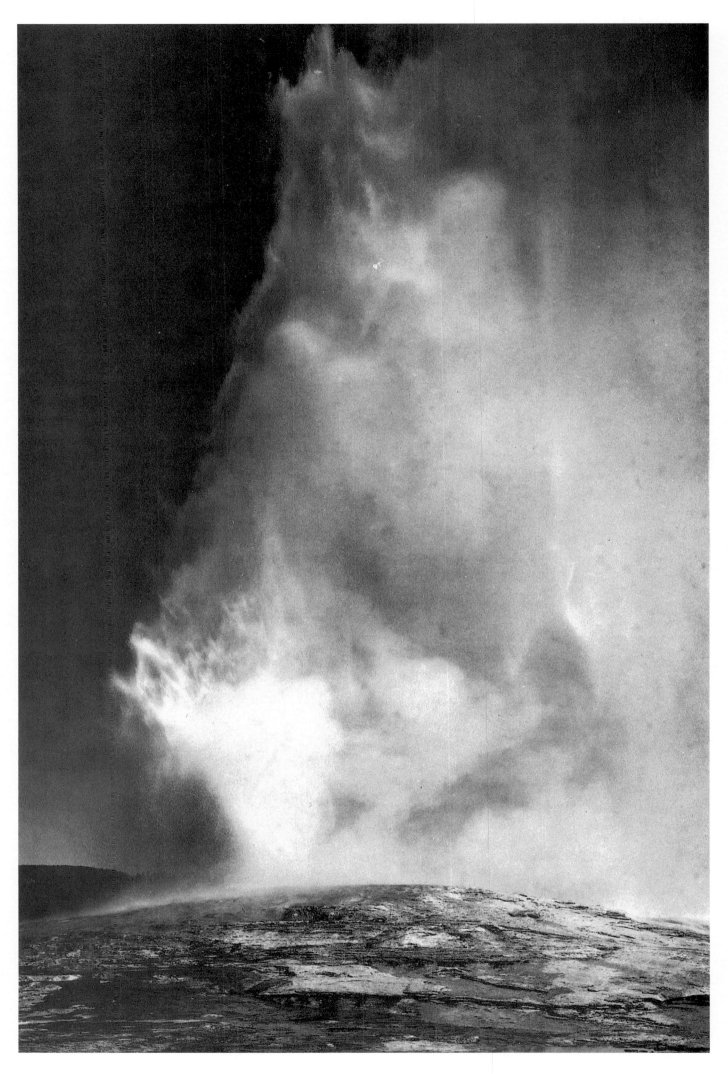

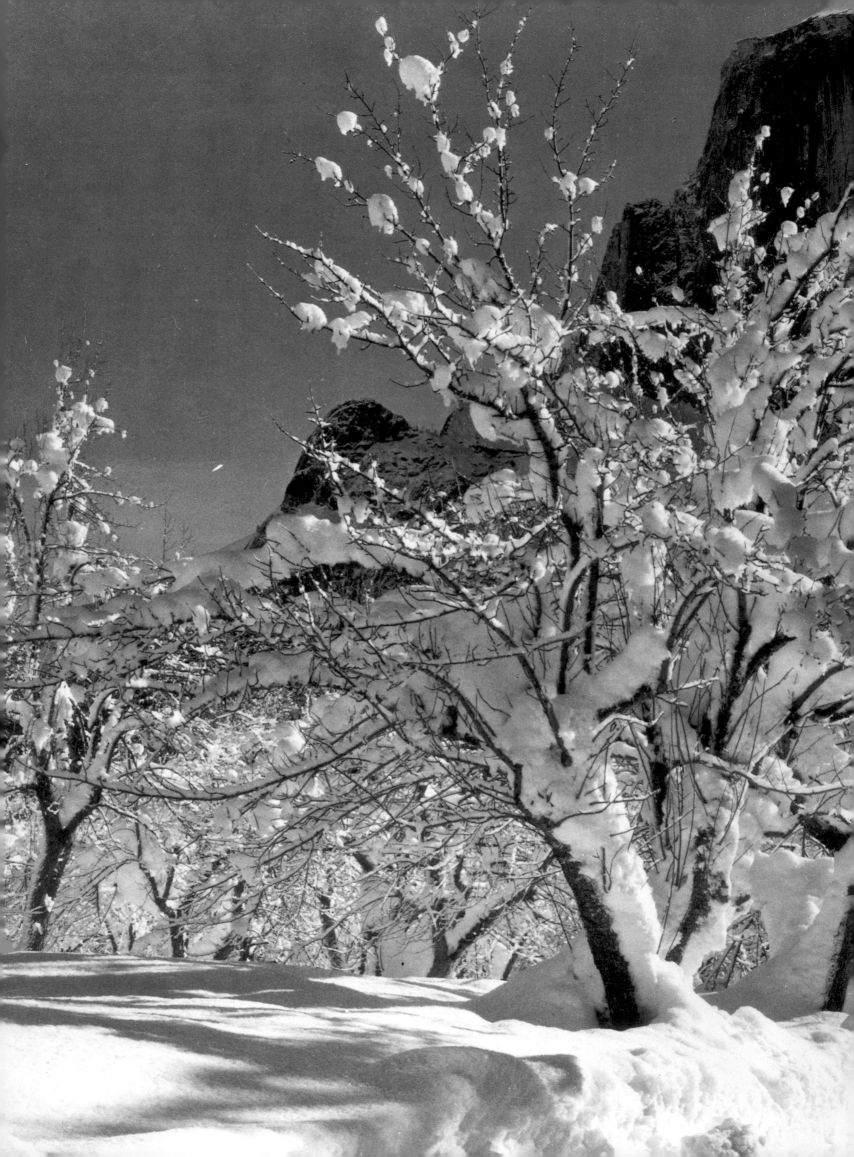

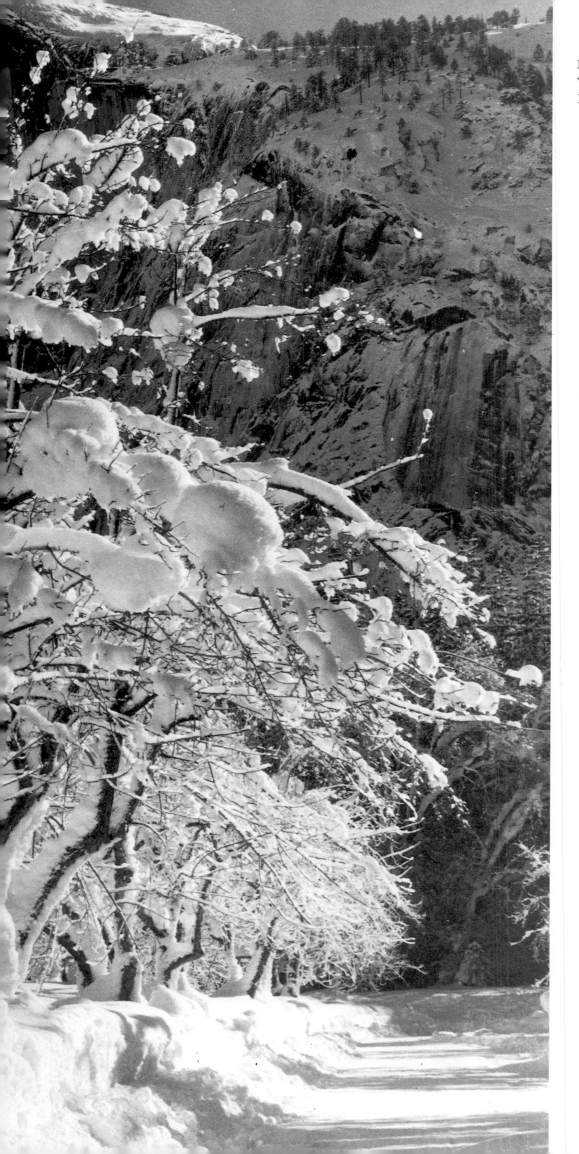

HALF DOME, APPLE ORCHARD,
YOSEMITE
Yosemite National Park, California

Below:
LICHENS
Glacier National Park, Montana

Opposite:
IN GLACIER NATIONAL PARK
Glacier National Park, Montana

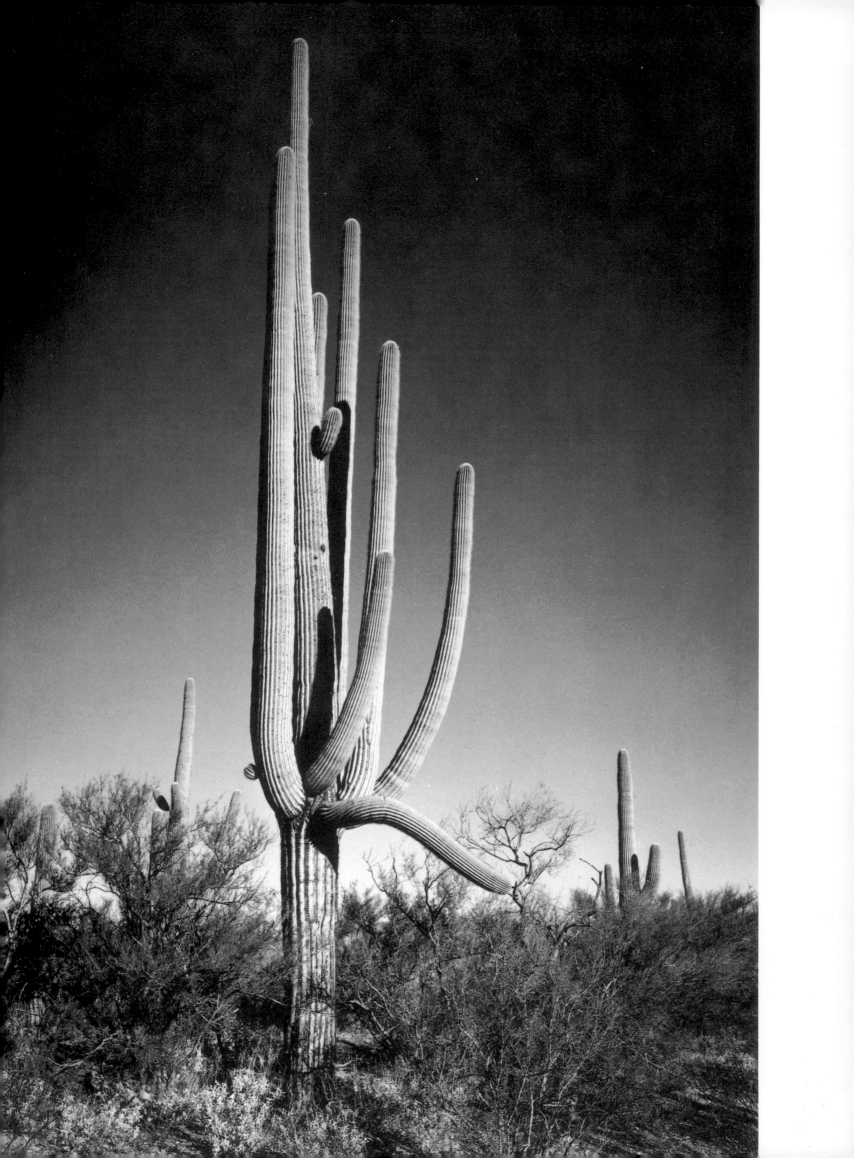

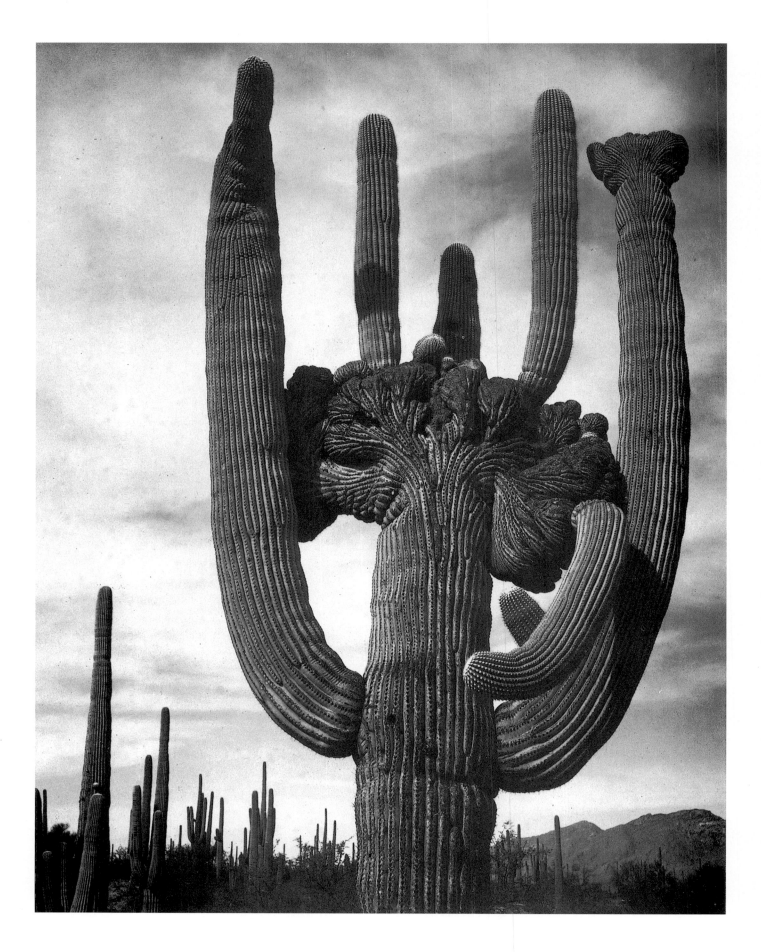

Opposite:
IN SAGUARO NATIONAL MONUMENT
Saguaro National Monument, Arizona

Above:
SAGUAROS
Saguaro National Monument, Arizona

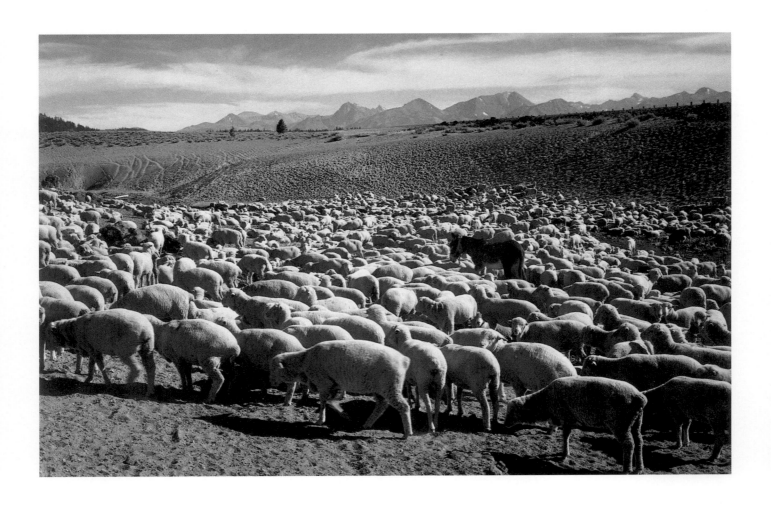

Flock in Owens Valley, 1941
Owens Valley, California

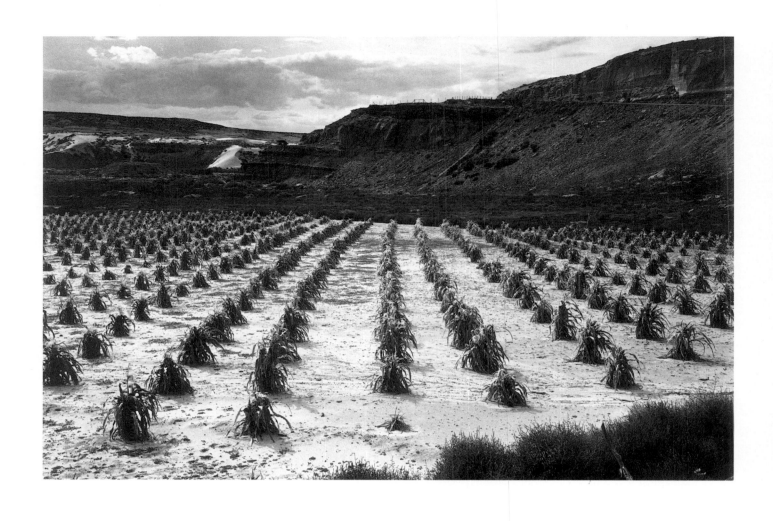

CORN FIELD, INDIAN FARM NEAR
TUBA CITY, ARIZONA, IN RAIN, 1941
Tuba City, Arizona

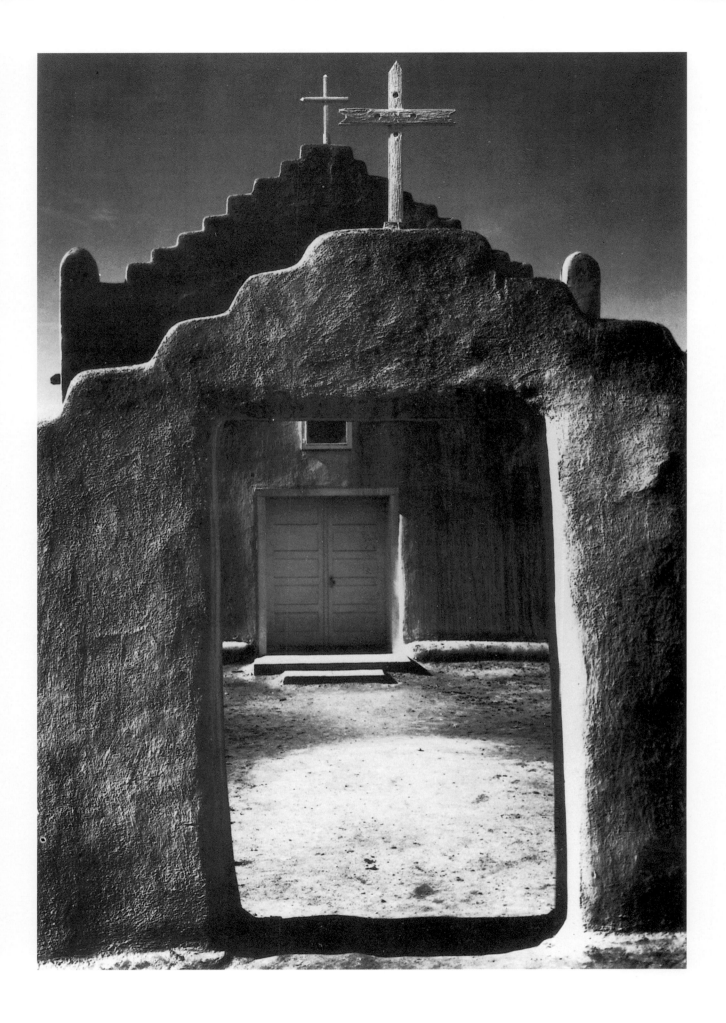

Opposite:
CHURCH, TAOS PUEBLO
Taos Pueblo, New Mexico

Below:
AT TAOS PUEBLO
Taos Pueblo, New Mexico

105

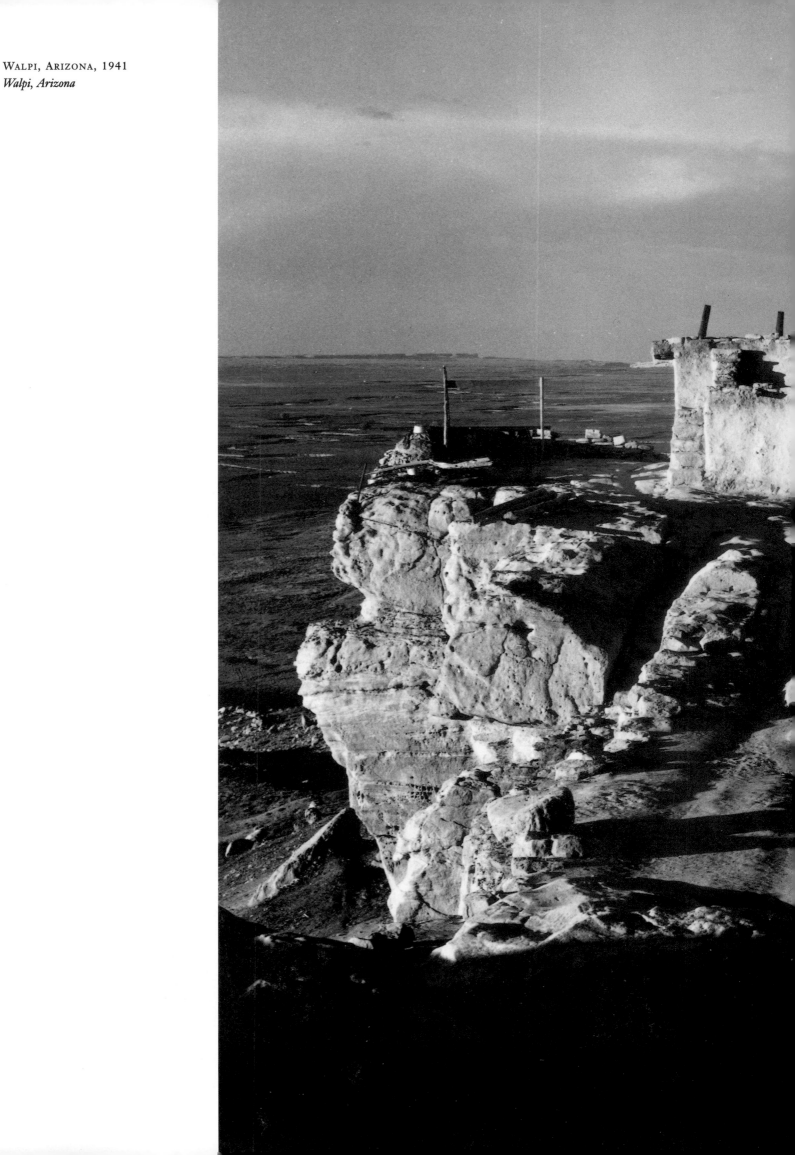

WALPI, ARIZONA, 1941
Walpi, Arizona

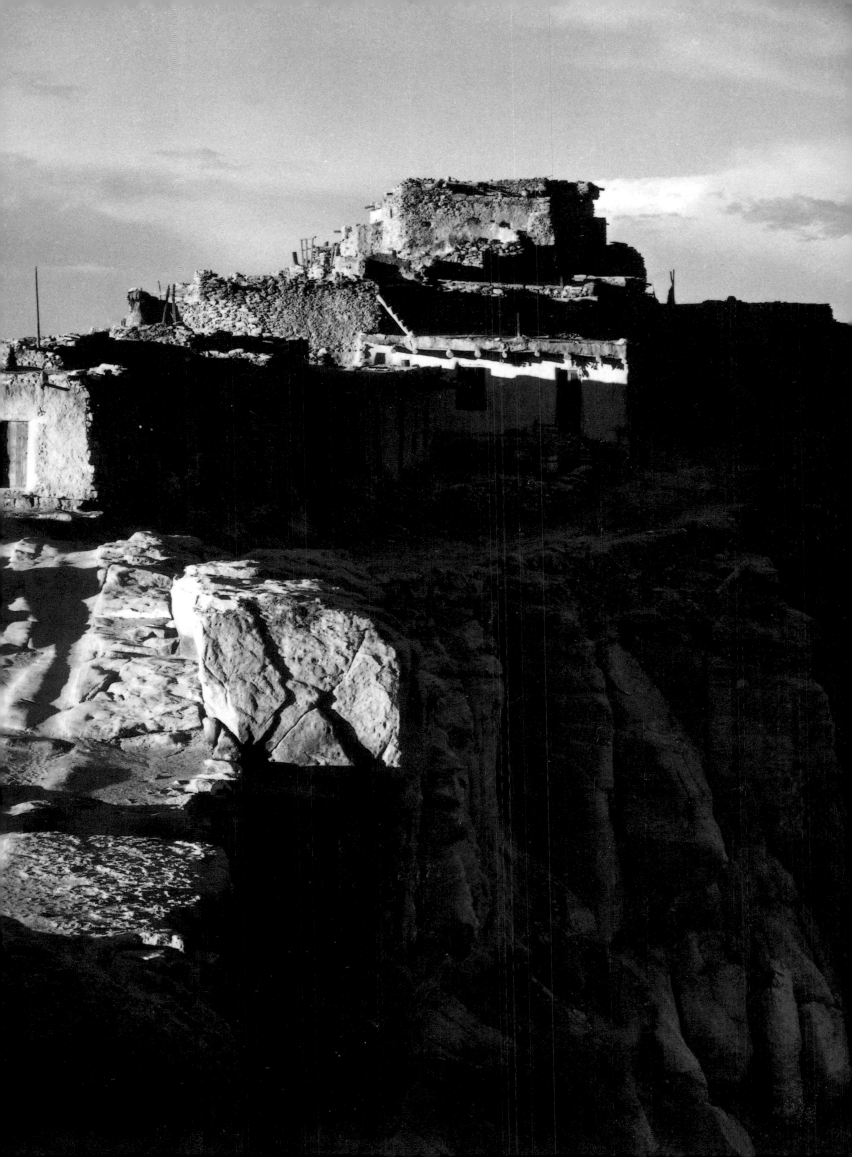

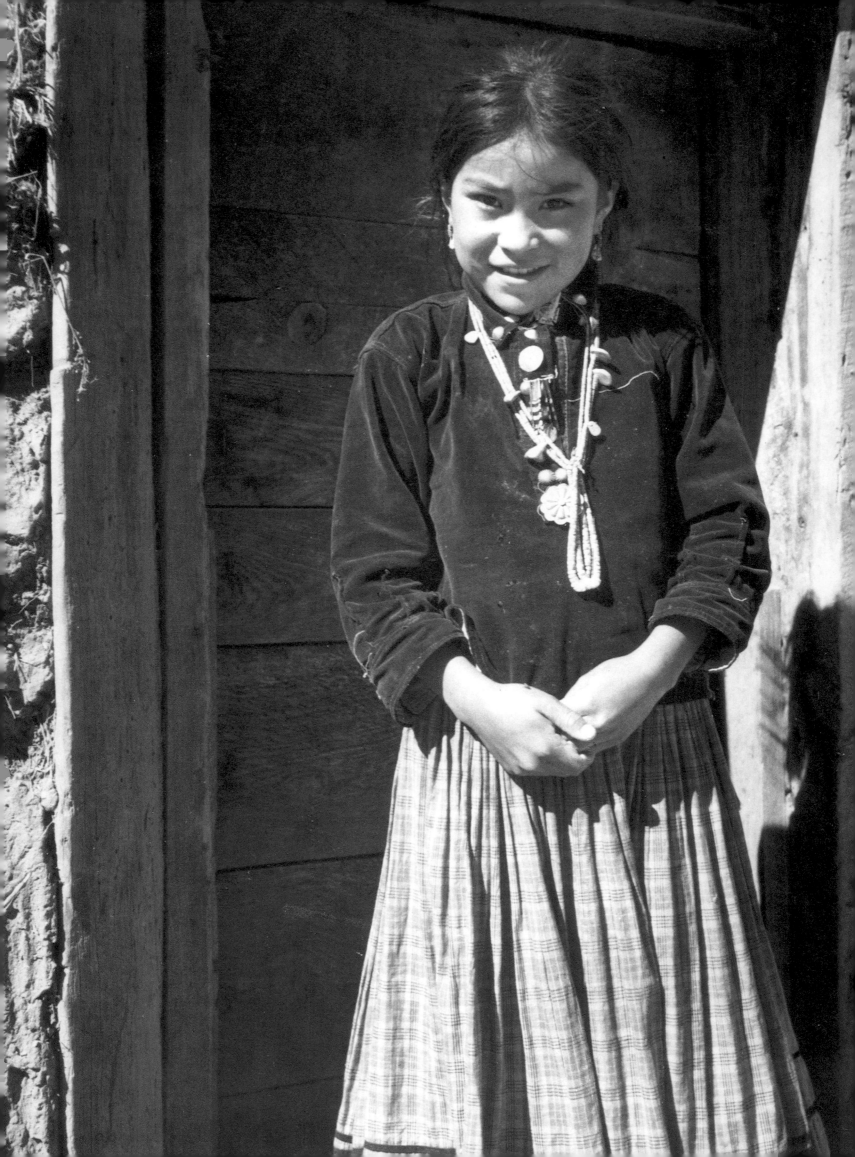

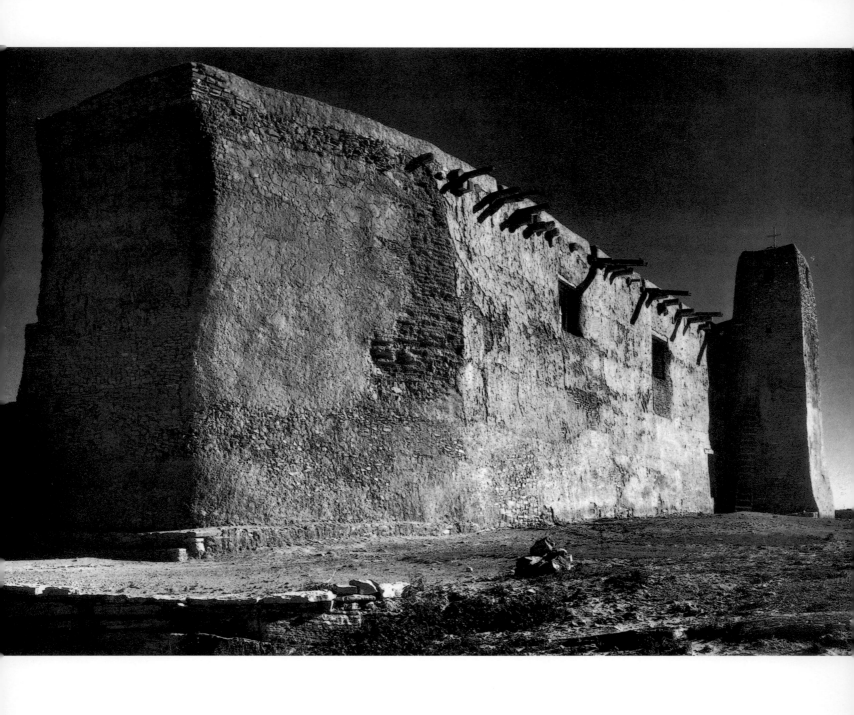

CHURCH, ACOMA PUEBLO
Acoma Pueblo, New Mexico

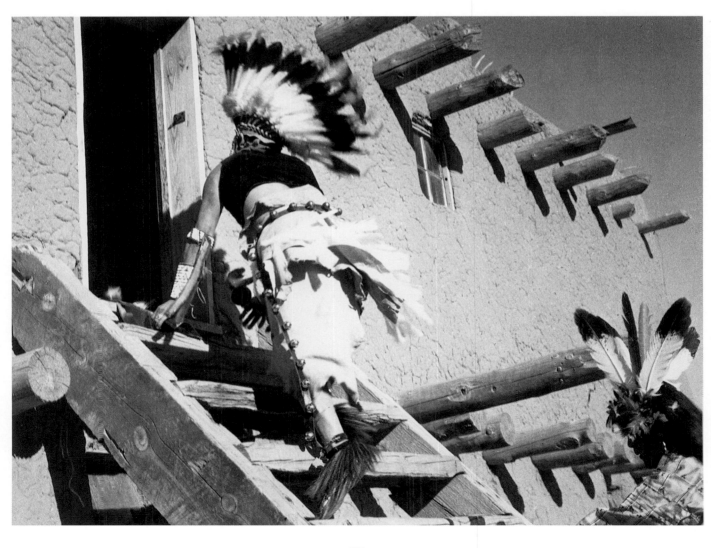

111

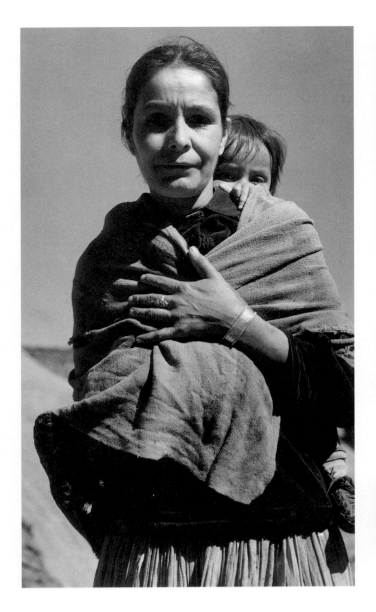

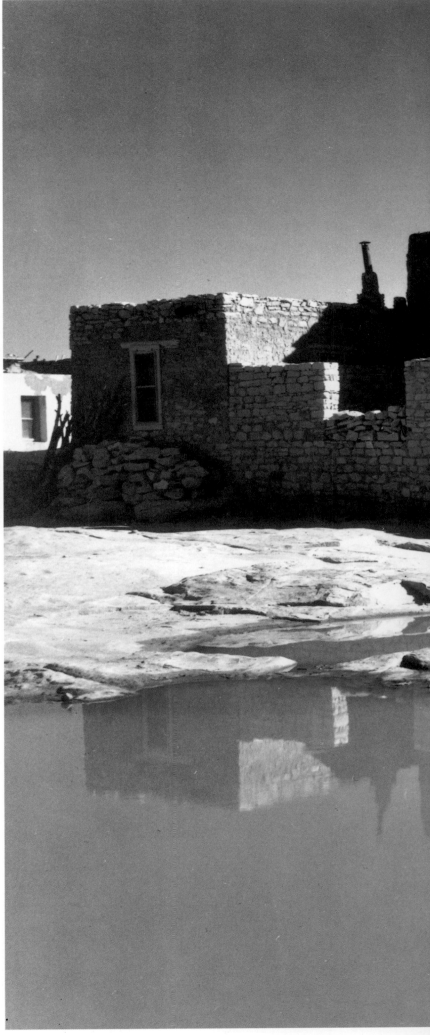

Above:
NAVAJO WOMAN AND CHILD
Canyon de Chelly, Arizona

Right:
ACOMA PUEBLO
Acoma Pueblo, New Mexico

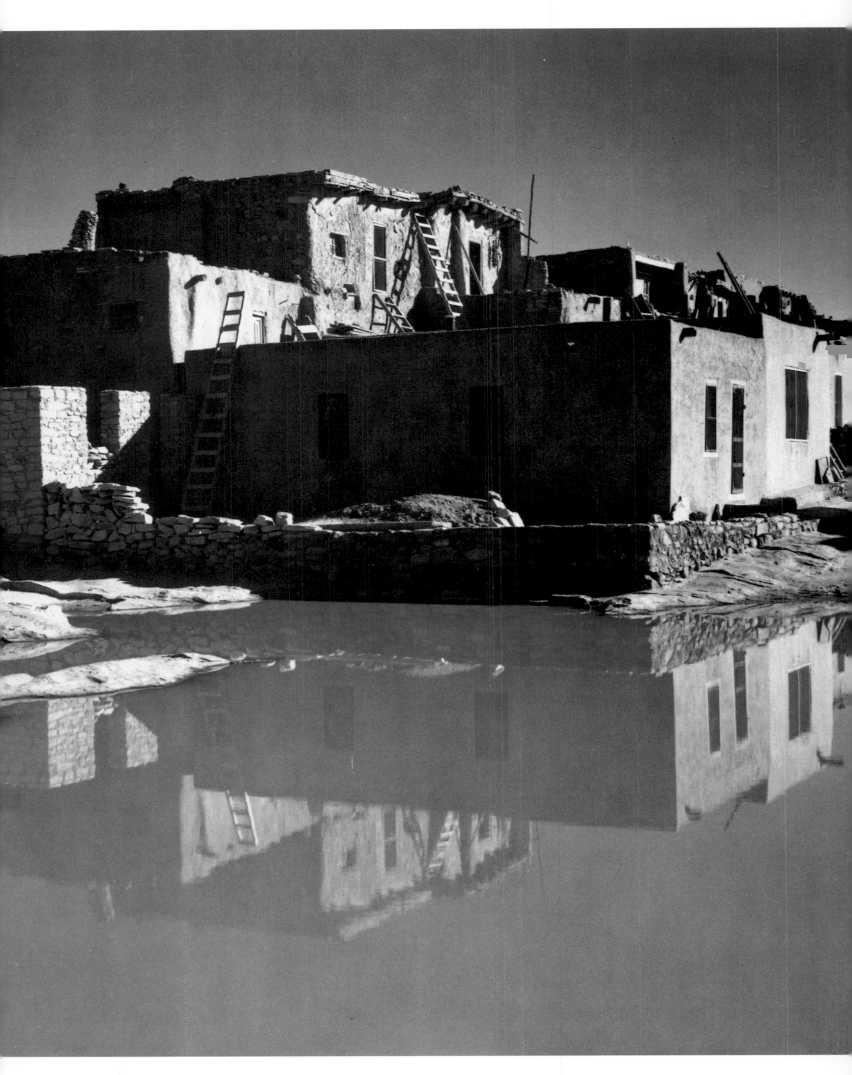

NAVAJO WOMAN AND INFANT
Canyon de Chelly, Arizona

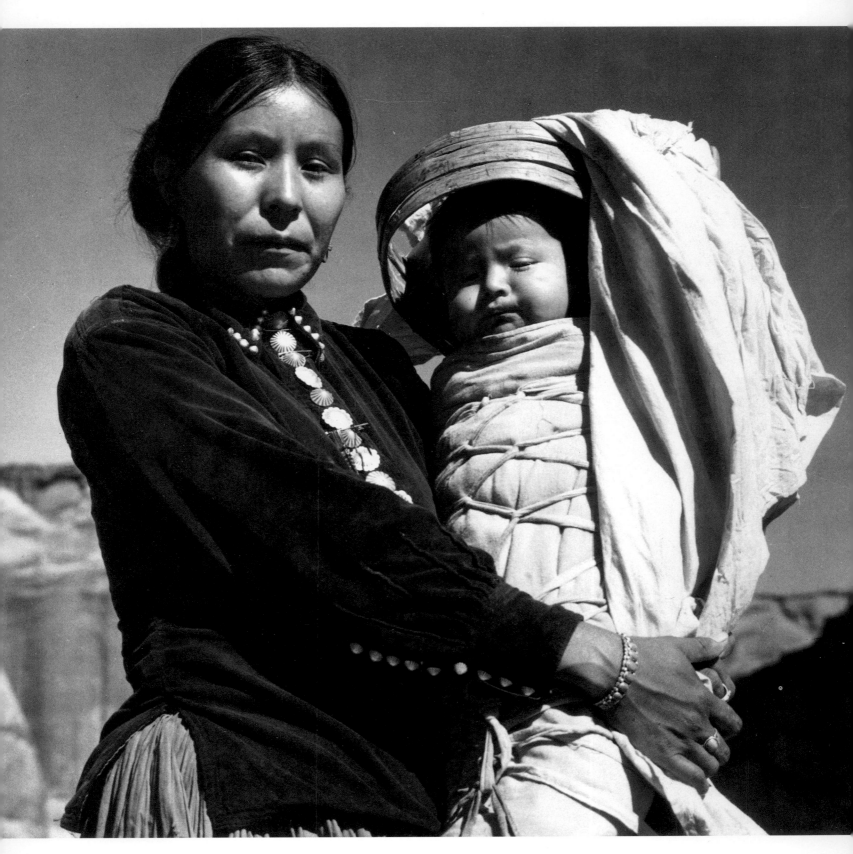

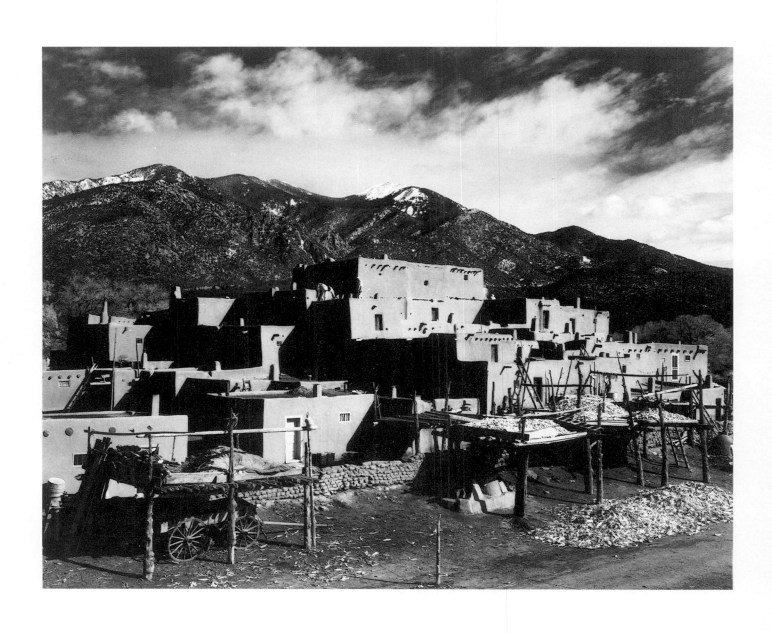

TAOS PUEBLO, NEW MEXICO, 1941
Taos Pueblo, New Mexico

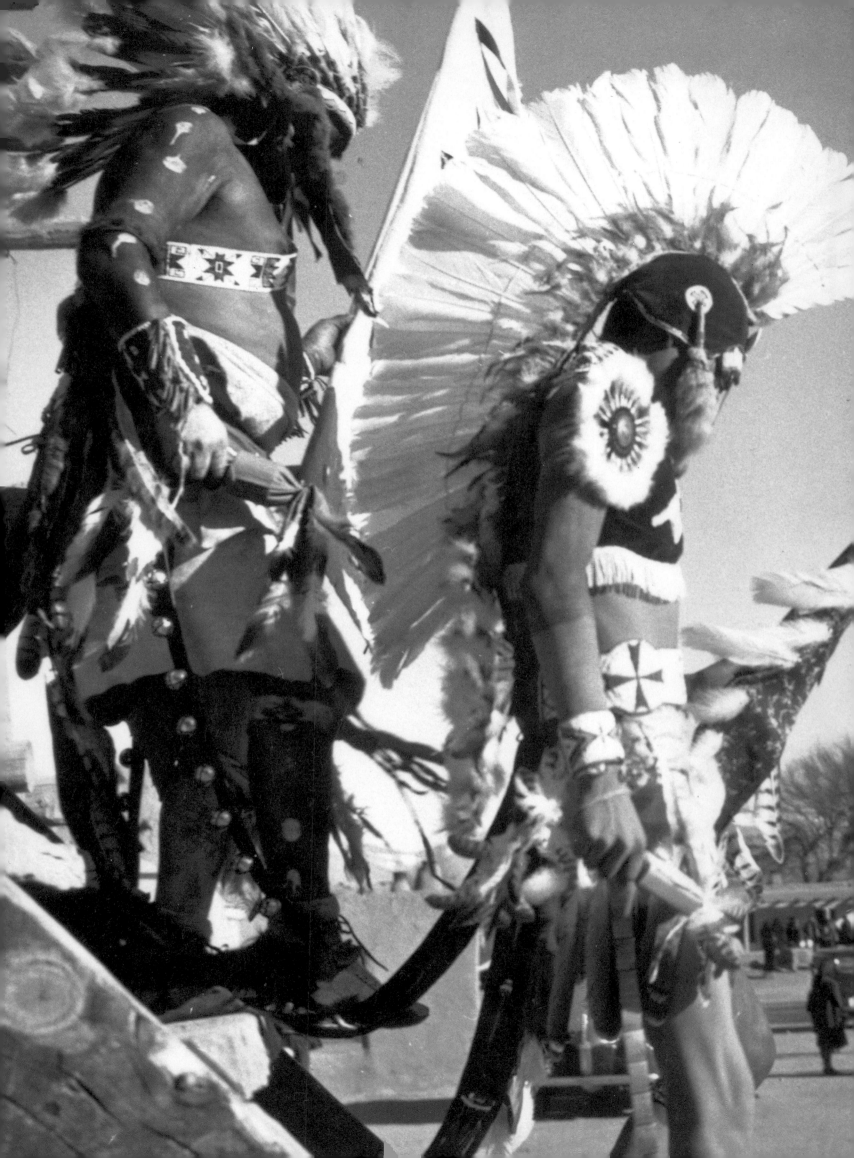

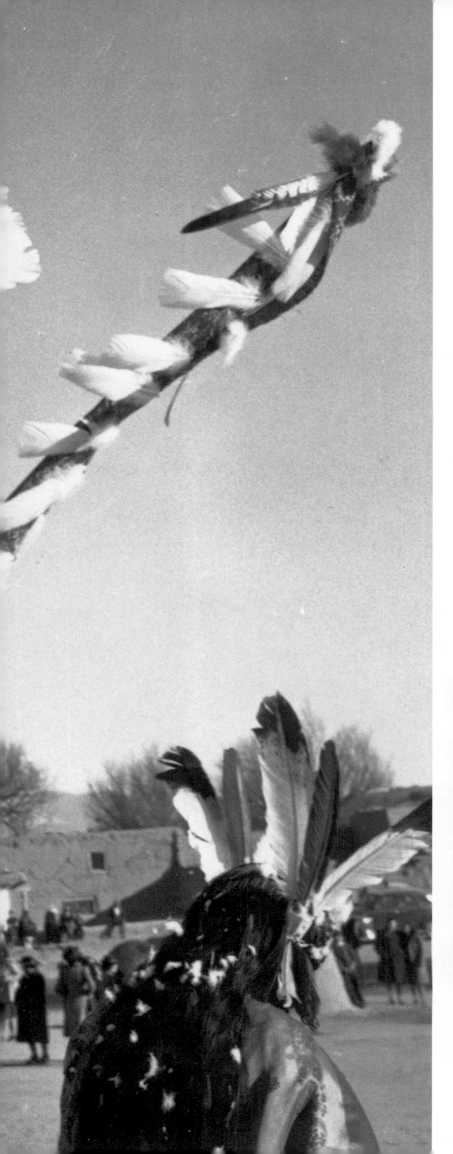

Left:
Dance, San Ildefonso Pueblo, 1942
San Ildefonso Pueblo, New Mexico

Below:
Dance, San Ildefonso Pueblo, 1942
San Ildefonso Pueblo, New Mexico

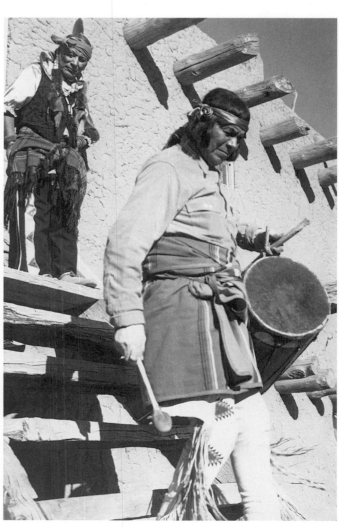

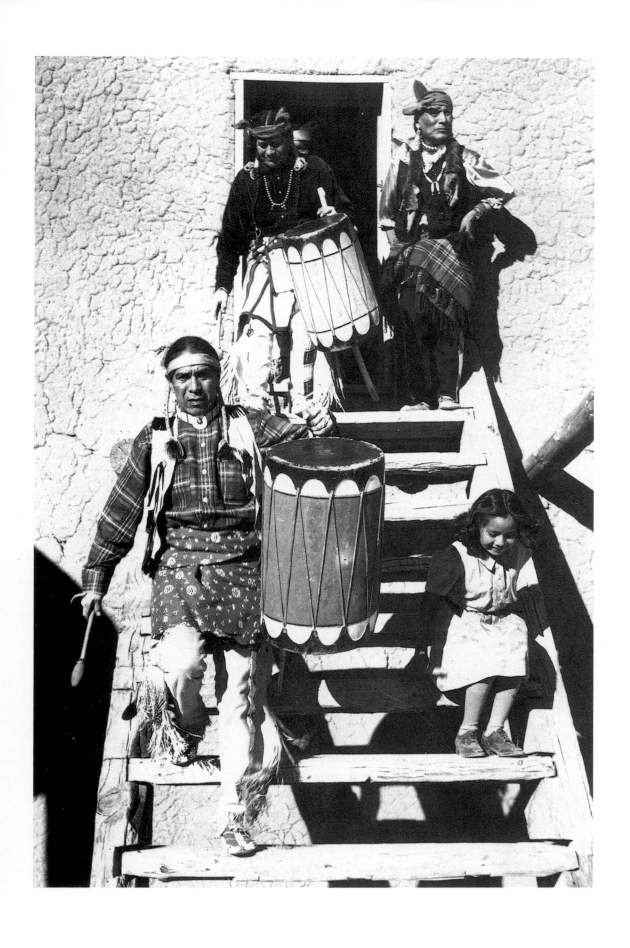

DANCE, SAN ILDEFONSO PUEBLO
San Ildefonso Pueblo, New Mexico

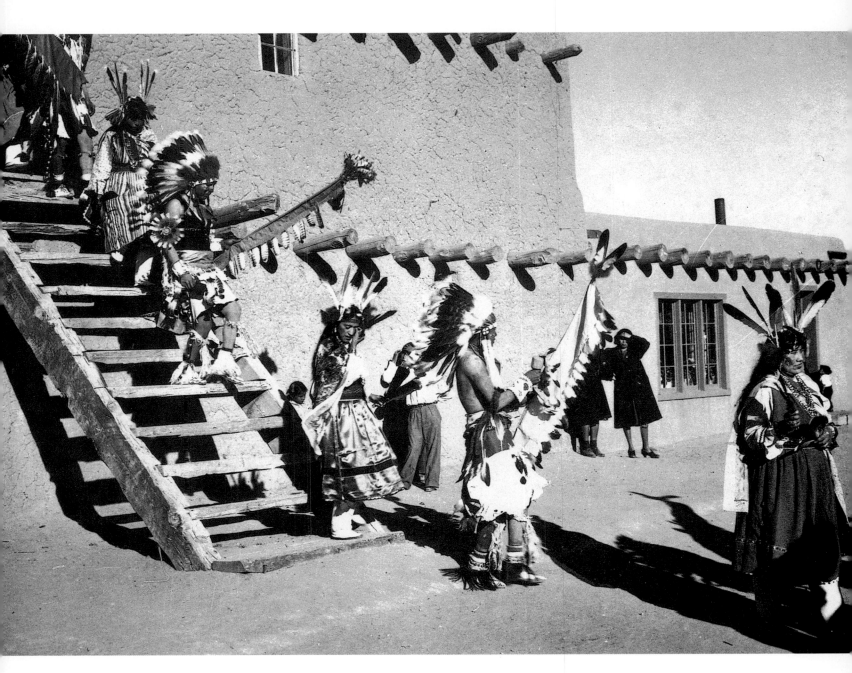

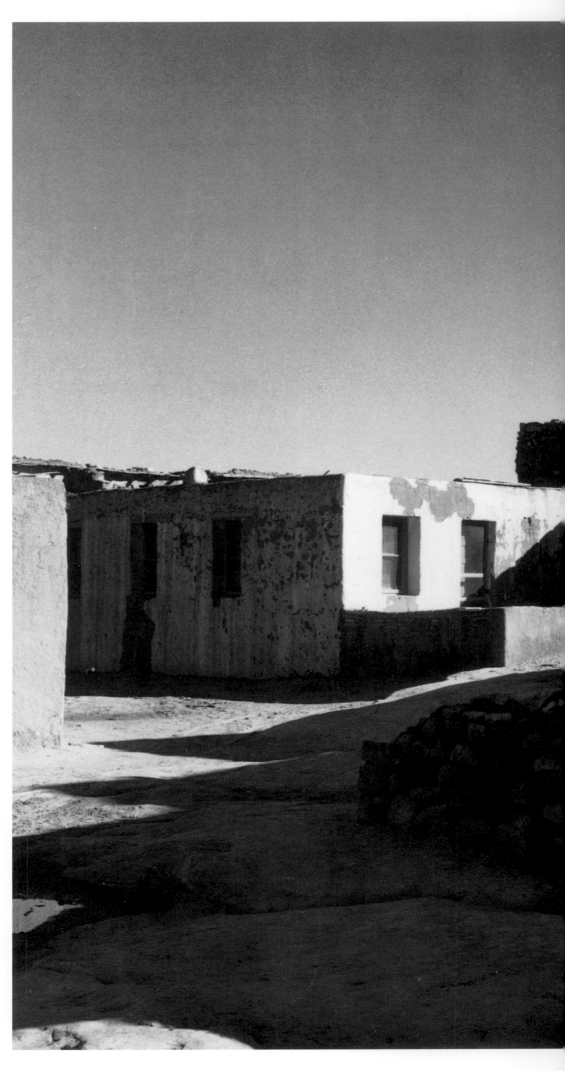

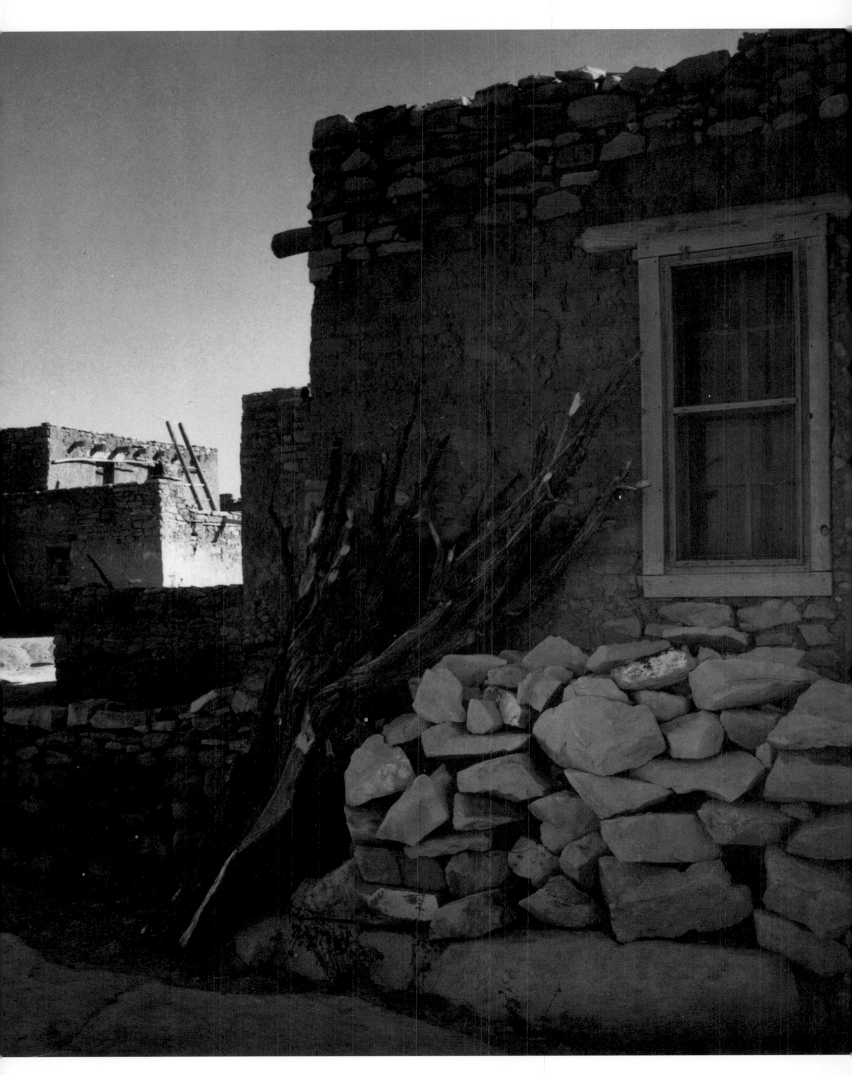

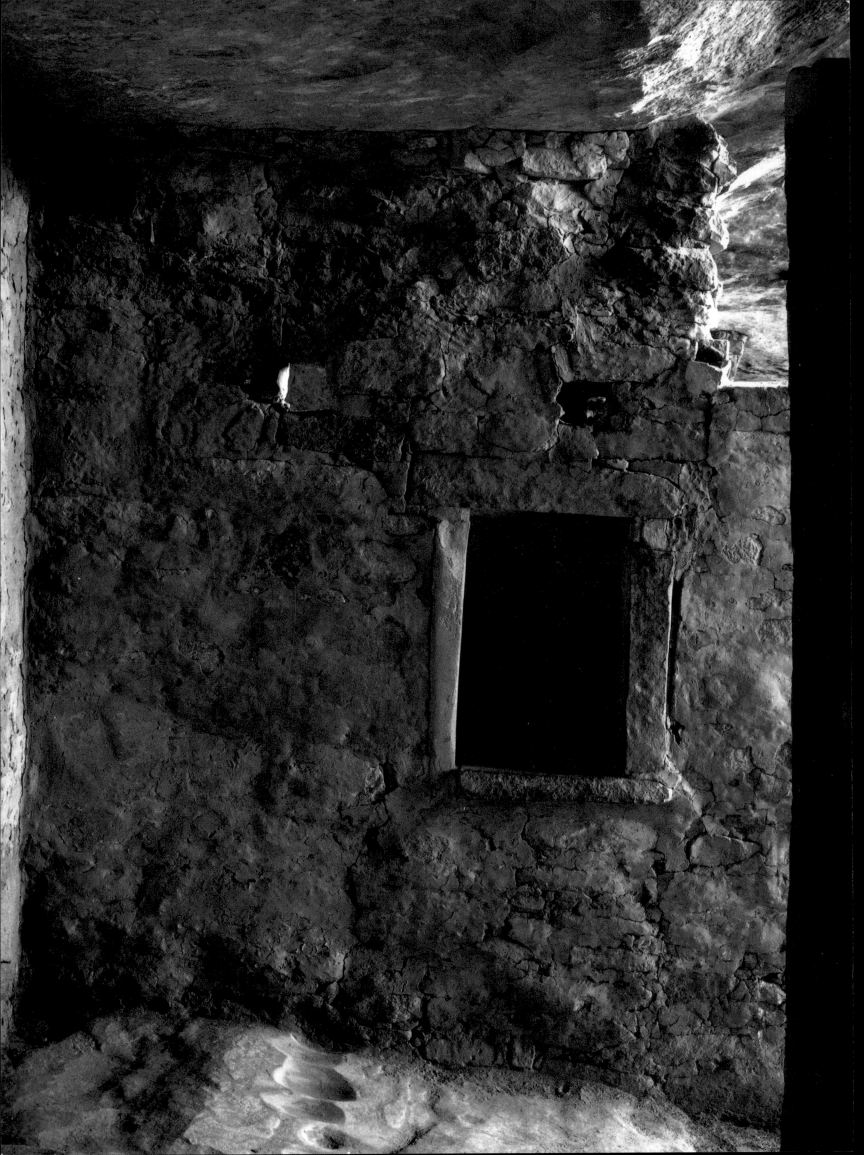

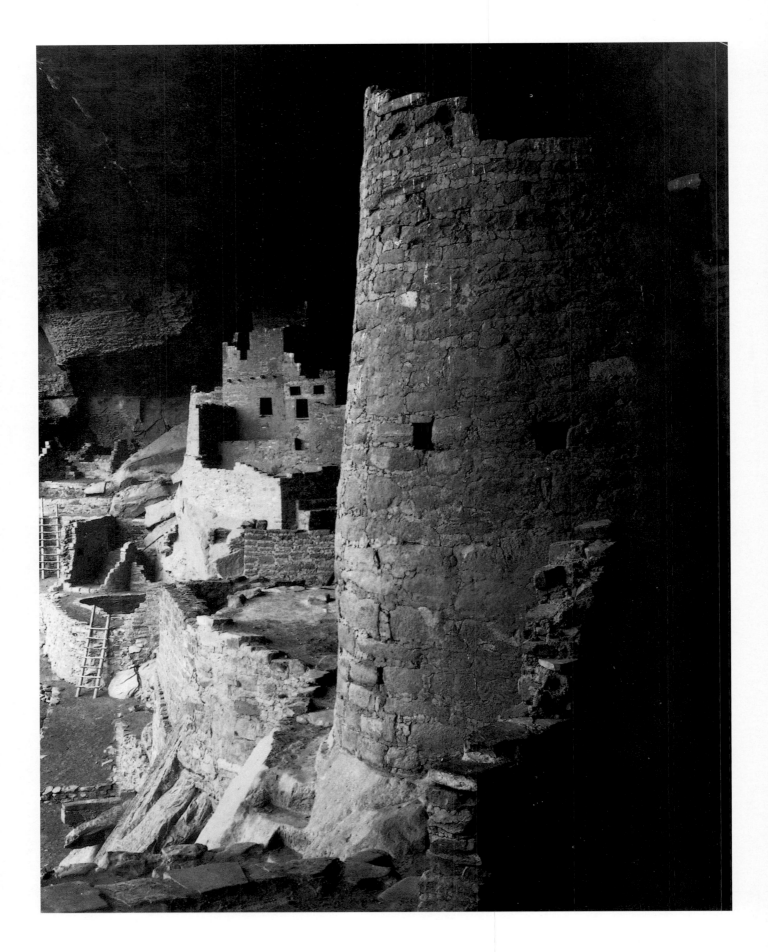

Opposite:
INTERIOR AT RUIN, CLIFF PALACE
Mesa Verde National Park, Colorado

Above:
UNTITLED
Mesa Verde National Park, Colorado

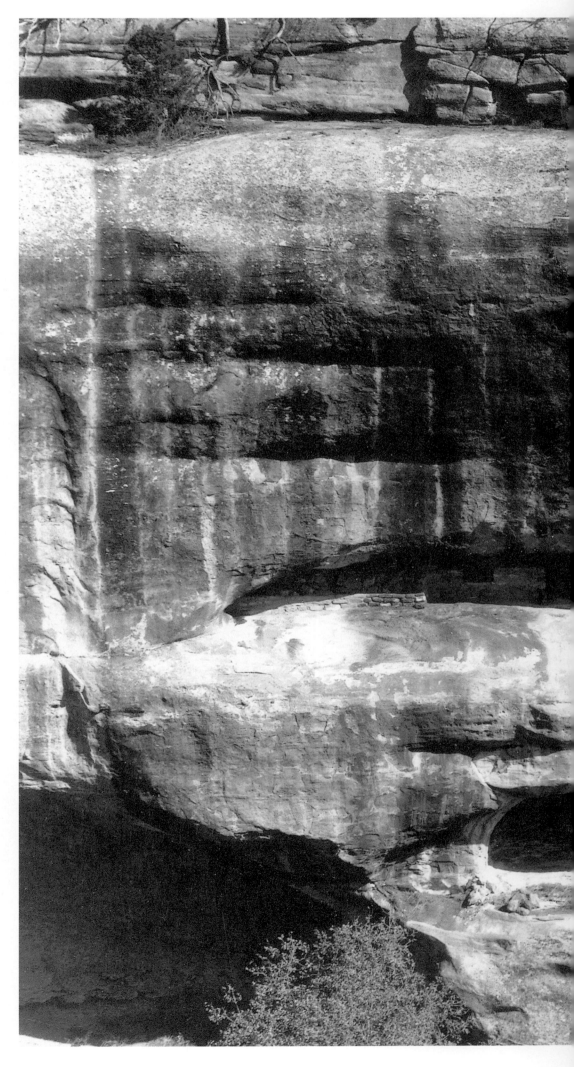

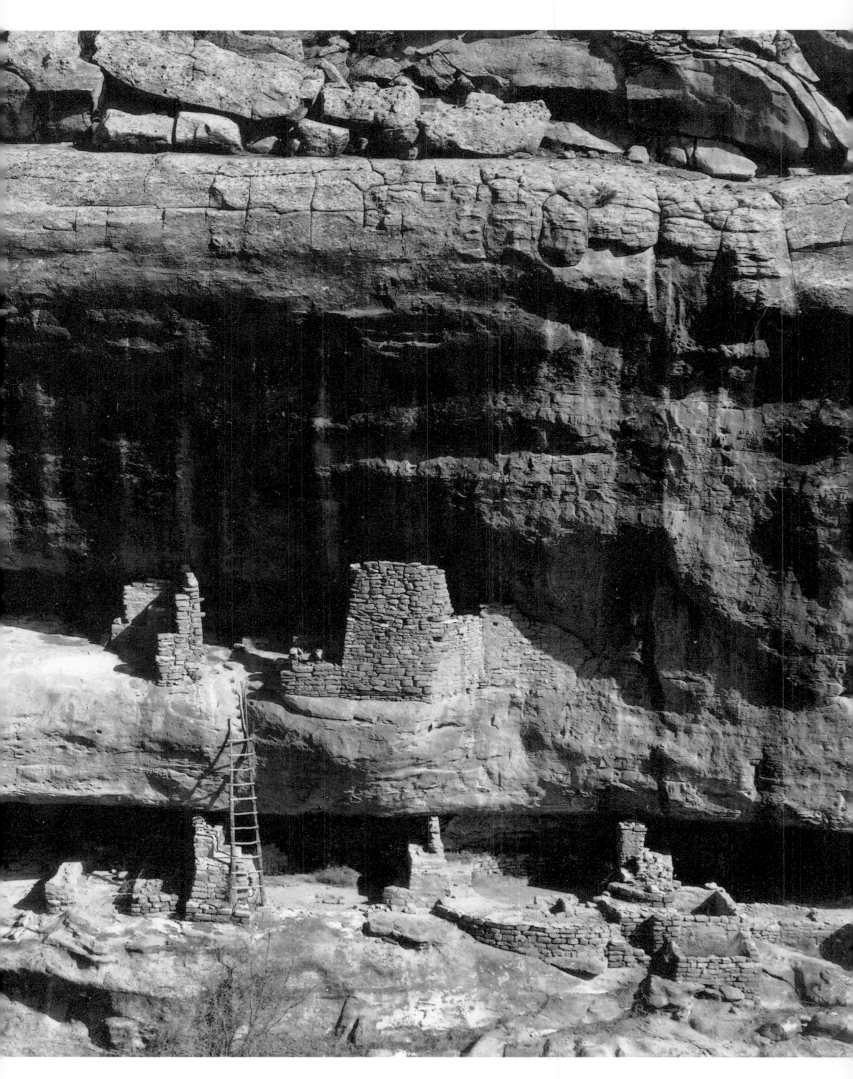

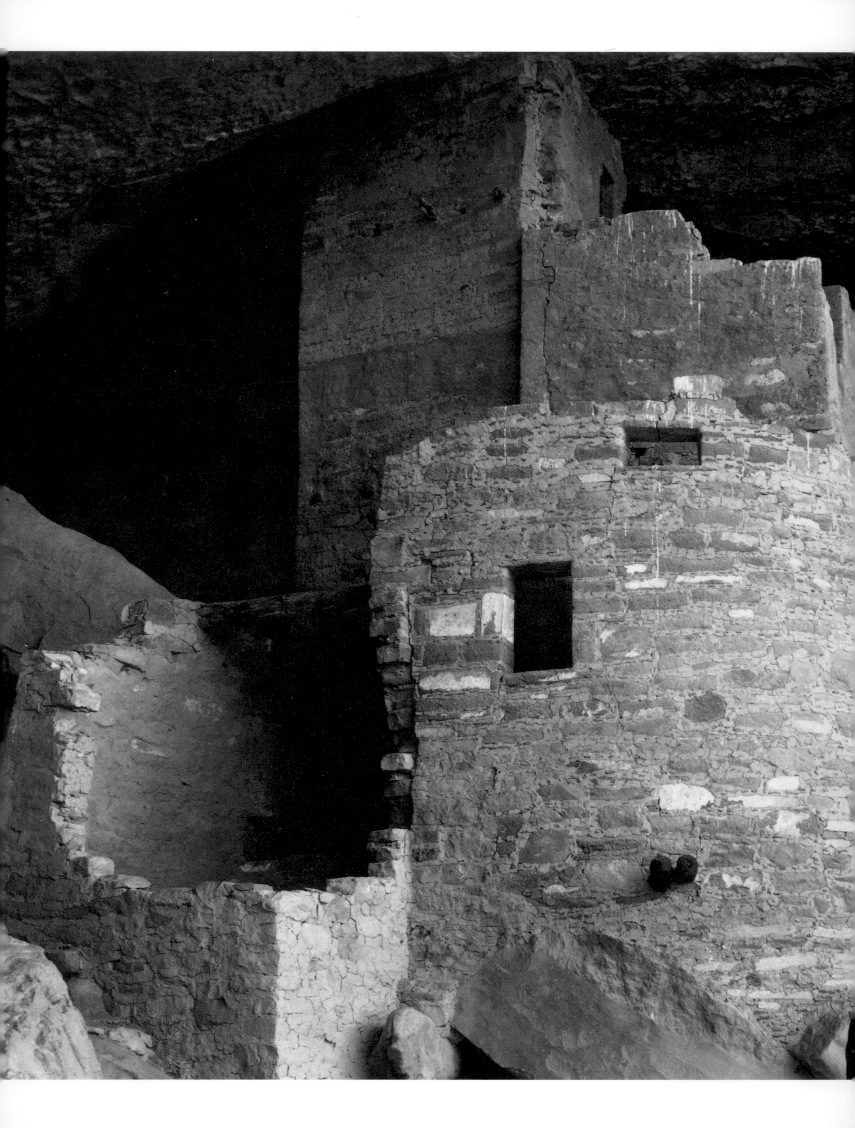

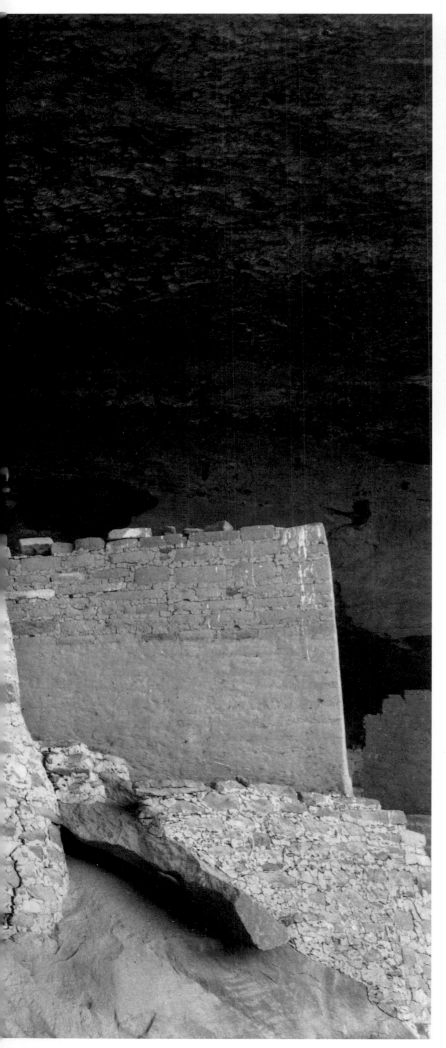

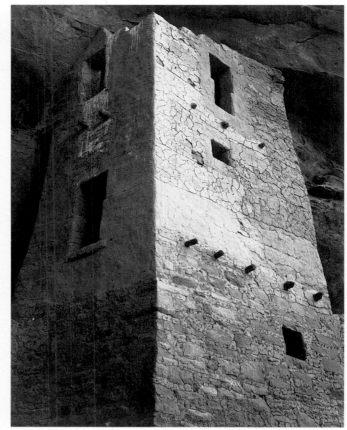

Left:
CLIFF PALACE
Mesa Verde National Park, Colorado

Above:
CLIFF PALACE
Mesa Verde National Park, Colorado

LIST OF PLATES